IMAGES
of America

MIRA MESA

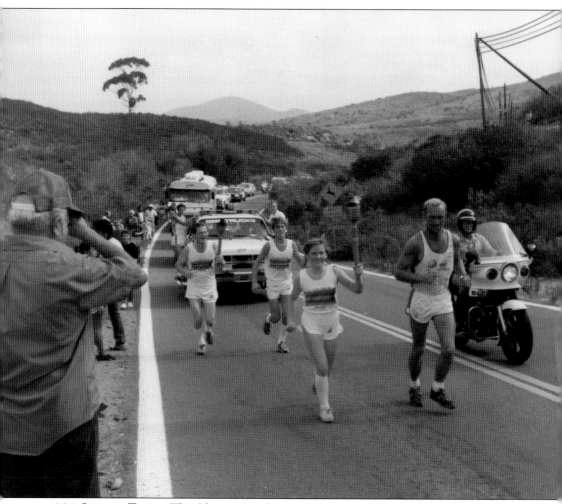

1984 Olympic Torch. The Olympic Torch passed through Mira Mesa on old Black Mountain Road on July 24, 1984. Crowds gathered at the side of the road to witness seeing the torch as it went by. In addition to this historic event, this picture shows the narrow, winding Black Mountain Road, which has since been widened to a six-lane major road. (SMM.)

On The Cover: Recess at Mira Mesa's First School. This photograph shows students playing outside the temporary Mira Mesa Elementary School the day classes began on December 1, 1969, in tract houses leased from the developer, Pardee, Inc., on Harlington Drive at Buckhurst Avenue. A section of Buckhurst Avenue was blocked for a playground near the two Harlington Drive houses serving the school's initial 23 students. Additional temporary "schools in houses" followed as Mira Mesa's population surged in the early 1970s. (Courtesy San Diego Unified School District, communications department archives.)

IMAGES of America
MIRA MESA

Pam Stevens

Copyright © 2011 by Pam Stevens
ISBN 978-0-7385-8203-0

Published by Arcadia Publishing
Charleston, South Carolina

Printed in the United States of America

Library of Congress Control Number: 2010934468

For all general information, please contact Arcadia Publishing:
Telephone 843-853-2070
Fax 843-853-0044
E-mail sales@arcadiapublishing.com
For customer service and orders:
Toll-Free 1-888-313-2665

Visit us on the Internet at www.arcadiapublishing.com

This book is dedicated to all Mira Mesans, past, present, and future.

Contents

Acknowledgments		6
Introduction		7
1.	Before the Beginning	9
2.	Affordable Homes—But Not Even A Grocery Store	17
3.	Schools Come To Mira Mesa	31
4.	"I Love Mira Mesa"	47
5.	Growing Pains	69
6.	Mira Mesa Matures	87
7.	Into the 21st Century	107
Bibliography		127

Acknowledgments

This book could not have been written without the help of many. First I'd like to thank my fellow community volunteers who encouraged me to take on the project of tracking down photographs and writing about Mira Mesa's history, as well as for their efforts over the years to make Mira Mesa a better place to live. Some of those efforts are documented within this book.

I'm extremely grateful to all the Mira Mesa residents and others who have shared their memories with me. Photographs credited as (PJS) were taken by my husband, Jeff Stevens, or me and/or come from our personal collection. I'd like to thank and identify the following additional photograph sources (in alphabetical order): Marlon Austria (MA); Carla Brandon, Mira Mesa Theatre Guild (CB/MMTG); Ted Brengel, Brengel Productions photography (TB); Ben Cagle (BC); Charlene Ellsworth (CE); Brett Feuerstein, Mira Mesa Shopping Center (BF/MMSC); Gail Fuhrman (GF); Marvin Gerst (MG); Hickman Elementary School archives (H), via Ann Quinn; Sharon and Mac McCollum (SMM); Marvin "Marv" Miles, Property Gallery (MM); Mira Mesa Branch Library staff scrapbook, via branch manager Lien Dao and youth services librarian Teresita Flores (MMBL); Janet Nelson, Friends of Los Peñasquitos Canyon Preserve (JN/FPC); Jim Papulas, Jim Papulas Photography (JP); Nancy and Bob Parker (NBP); Barbara and Joe Peluso (BJP); Sandburg Elementary School archives (S), via principal Laurie Hinzman and her very helpful office staff; San Diego Unified School District, communications department archives (SDUSD), via Jack Brandais; Bernard Senick (BeS); Lily Supnet (LS); Brian Swanson (BrS); Michelle Tsai, Mira Mesa Living magazine (MT/MML), and Walker Elementary School archives (W), via school librarian Sheila Guzman and mini-school teacher Roma Weaver.

I'd like to thank my Arcadia Publishing editor, Debbie Seracini, for helping guide me through this process that turned out to be much more complicated than I had envisioned but ultimately fulfilling.

Finally, I am deeply grateful to my husband, Jeff Stevens. His technical assistance in scanning the photographs for this book, his knowledge as a longtime community volunteer in Mira Mesa, his photographic and editorial skills, his sound project management advice, and his bringing me hot coffee when needed are all greatly appreciated!

Introduction

Mira Mesa is a suburban community in the northern part of the city of San Diego with many of the qualities of a small town. Mira Mesa is San Diego's largest suburb, with more than 78,000 residents, stretching from Marine Corps Air Station Miramar on the south to Los Peñasquitos Canyon Preserve on the north, and from Interstate 15 on the east to Interstate 805 on the west. As a community, Mira Mesa is still young—just over 40 years old—but is old enough to have a fascinating history. From its beginning in 1969, when "Mira Mesa" conjured up an image of tract homes on an isolated mesa and not much more, Mira Mesa has grown to become the bustling, happily multiethnic, centrally located community within the City of San Diego that it is today.

This is a look at Mira Mesa's history from earliest days to the present, starting with an overview of the Spanish rancho period through the 1960s, with a primary focus on Mira Mesa's rapid growth and development starting in 1969. In 1980, ten years after the community began, Mira Mesa was much smaller in population than today, but it already had a number of basic services—local schools, parks, a branch public library, a post office, and several local shopping centers—that had been totally lacking just 10 years beforehand.

The history of the 1970s was fresh in the minds of the neighbors and residents who contributed to this book by telling about mothers' marches for schools and how schools and parks weren't given to the community by an unknown government body or omniscient development planner but instead came about due to the desires, voices, and efforts of Mira Mesa residents themselves. There was still a pioneer spirit in Mira Mesa in 1980, stemming from factors set in play in the 1970s. To some extent, that came simply from a sense of being isolated from other parts of San Diego but also from a "can do" attitude that Mira Mesans can take care of things themselves. Today Mira Mesa is no longer isolated, but the community's pioneer friendliness, "can do" spirit, and "neighbor helping neighbor" attitude have remained.

Mira Mesa today is happily multiethnic, with a large Filipino as well as Vietnamese population. Lumpia, pancit, and Philippine barbecue are popular foods at community events. "Little India," a collection of restaurants and shops in southeast Mira Mesa, draws customers from throughout the community as well as San Diego in general.

Forty years after its first tract homes sprang up on the mesa, Mira Mesa in 2010 is a vibrant small town suburb, a good place to live and raise a family, to work and/or to retire, and a community that more than 78,000 San Diegans are happy to call home.

One
BEFORE THE BEGINNING

Prior to 1969, there was no Mira Mesa, but there was Rancho Santa Maria de los Peñasquitos on the community's northern edge in Peñasquitos Canyon. The area was a Mexican land grant to Capt. Francisco Maria Ruiz in 1823 and remained a working ranch until 1962. The restored adobe ranch house seen today was built in 1862 and incorporates in its oldest wing three walls from an earlier adobe structure, according to Images of America: *Ranchos of San Diego County*, by Lynne Newell Christensen, Ph.D., and Ellen L. Sweet. One small herd of cattle grazed until 1989 when local equestrians joined in helping with a last cattle drive. Today Los Peñasquitos Canyon Preserve is Mira Mesa's wild backyard, a special historic and natural resource for the community as well as a city and county open space preserve for all San Diegans.

"Vaseyville," a collection of cottages, a general store (and later gas station), and a one-room schoolhouse near what is now the intersection of Miramar Road and Kearny Villa Road, was a settlement founded in 1890 by John Wycliff Vasey and his wife, Elizabeth. It was a remote and rustic life for the scattered residents. The only water available was rainwater collected in cisterns. In *Miramar Before the Planes*, Ruby Mae Peters tells the story of that settlement, including a photograph of the one-room school building in operation from 1912 to 1958. According to Peters, the remaining cottages in the area were removed in the 1960s with expansion of the air base.

In the 1960s and early 1970s, much of the Mira Mesa area remained a rocky, brush-covered mesa, home to rattlesnakes, rabbits, and coyotes, with finger canyons leading to Lopez and Peñasquitos Canyons to the north, or Rattlesnake and Carroll Canyons to the south, and dropping down to Sorrento Valley on the west. Deer lived in the canyons. San Diego residents of that time remember coming to the area to hike or hunt jackrabbits. The "olive grove," a prominent cluster of mature trees, was a landmark on the mesa in the west.

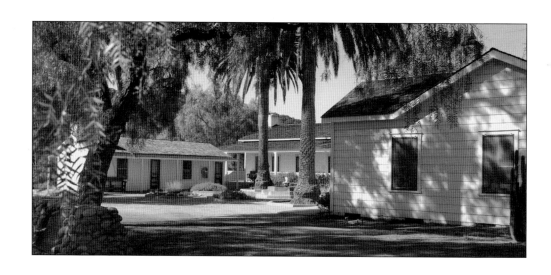

RANCHO SANTA MARIA DE LOS PEÑASQUITOS. Visitors can imagine life as it was in the "Johnson-Taylor" era (1860s to 1880s) at the adobe ranch house in Los Peñasquitos Canyon Preserve, which has been restored by the County of San Diego. The original structure on this site was a modest adobe built in 1824 by Capt. Francisco Maria Ruiz. In 1859, George Alonzo Johnson married Estefana Alvarado, whose brother Diego Alvarado had inherited the rancho. Johnson, who became known operating steamboats on the Colorado River delivering supplies to the army, expanded the ranch house significantly in 1862 as a home for himself, his wife, and their family. Three walls of the original 1824 adobe can be seen today as walls in the main ranch house conference room. The ranch was owned in the 1880s by Jacob Shell Taylor, founder of Del Mar. (Both JN/FPC.)

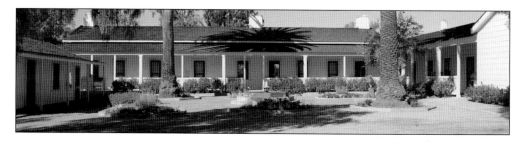

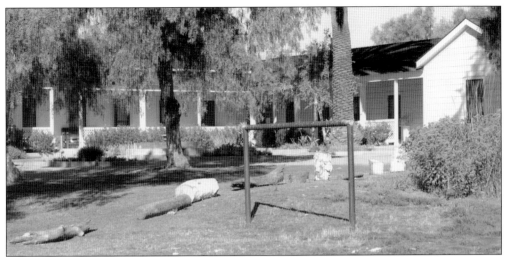

ADOBE RANCH HOUSE WITH HITCHING POST. Equestrians today can tie their horses in front of the adobe just as everyone did in the pre-automotive era. Canyonside Stables—a City of San Diego lessee within the preserve on the east side of Black Mountain Road and the site of the historic Mohnike adobe and barn—offers horse boarding as well as riding lessons through its sub-lessee, Horsebound. (JN/FPC.)

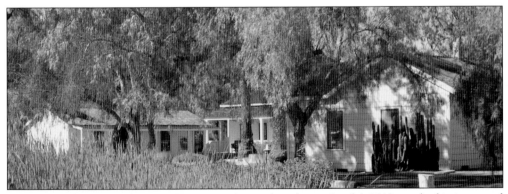

PEÑASQUITOS ADOBE AND NEW WETLAND. An earthquake on April 4, 2010, resulted in increased flow in the rancho's artesian spring and triggered a second spring, causing a new wetland area east of the ranch house, as evident in this October 2010 photograph. A similar increase in wild springs activity after an earthquake was reported in 1872, according to *Wild Springs Have Sprung*, written by San Diego County Park Ranger Rusty Rodes in the Friends of Los Peñasquitos Canyon Preserve Newsletter for July–September 2010. (JN/FPC.)

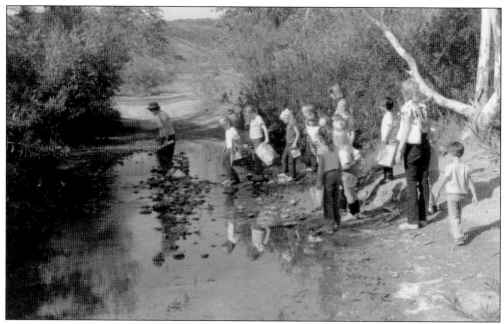

CROSSING PEÑASQUITOS CREEK. This group of hikers in the mid-1980s crossed Peñasquitos Creek on stones not far from the adobe ranch house in much the same way they would have done 100 years beforehand. Today Los Peñasquitos Canyon Preserve has many footbridges across the creek, but hikers as well as equestrians still ford the creek at several places the old-fashioned way. (PJS.)

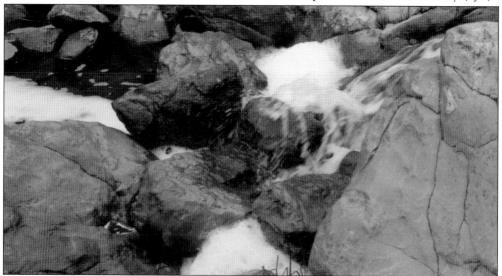

WATERFALL, PEÑASQUITOS CREEK. About 3 miles from Los Peñasquitos Canyon Preserve's parking/staging areas at Black Mountain Road on the east or Sorrento Valley Boulevard on the west, a small but scenic waterfall on Peñasquitos Creek cascades over boulders. In Spanish, *los peñasquitos* means "little rocks" or "little cliffs," referring to the canyon walls, which are steep on the Mira Mesa side and more gently sloping on the north to Rancho Peñasquitos and Carmel Valley. Water flow varies depending upon whether the year has been wet or dry, but the topography of the falls has remained the same over the years. This photograph was taken in 1989. (PJS.)

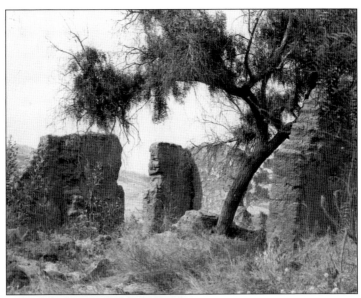

EL CUERVO ADOBE. At the west end of Peñasquitos Canyon near Sorrento Valley, Diego Alvarado (1836–1919) built an adobe ranch house called El Cuervo, meaning "crow" or "raven" in Spanish. Today just a few walls of El Cuervo still stand, protected as a historic landmark by a covering roof erected by the City of San Diego. This 1970s photograph shows El Cuervo before the roof structure was erected. (NBP.)

JOHN "JACK" NORTHROP ON HIS HORSE. John "Jack" Northrop, Ph.D., was a familiar sight on the trails of Peñasquitos Canyon, the Del Mar Mesa, and Carmel Mountain Preserve for many years. An active member of the Los Peñasquitos Canyon Preserve Citizens Advisory Committee until his death in 2009 at age 86, Northrop used his skills as a geologist and passion as an equestrian who loved the wild places of Peñasquitos Canyon and its surroundings to write books about the area's geology and riding trails. He also wrote many articles for the Friends of Los Peñasquitos Canyon Preserve newsletter about geology, wildlife, and the last cattle drive in the preserve. (MG.)

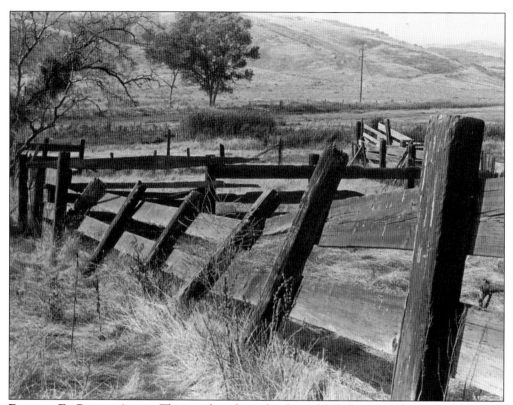

FENCE AT EL CUERVO ADOBE. This weathered wooden fence, likely from an old corral at El Cuervo Adobe, is shown in a 1970s photograph. Cattle roamed in Peñasquitos Canyon even after Los Peñasquitos Canyon Preserve was established in 1979 as a San Diego City/County natural open space park. Increasing suburban development, including construction of Calle Cristobal/Sorrento Valley Boulevard down the nose of Lopez Ridge, as well as concerns about the compatibility of grazing cattle with wildlife and native plant life, led to a "last round-up" of the remaining cattle in 1989. (NBP.)

1920s HOUSE, SORRENTO VALLEY. On Mira Mesa's western border, this 1920s–era house was abandoned by the time Brian Swanson took this photograph in July 1971 but was still standing as an example of the isolated residences in the area up until the suburban community of Mira Mesa began in 1969. The house was located on the north side of Sorrento Valley Road, in the 10800 block, near the railroad tracks. (BrS.)

COBBLESTONE "WISHING WELL," MIRAMAR ROAD. Perhaps this low cobblestone structure was a remnant of Vaseyville. This photograph was taken in July 1971 on the north side of Miramar Road, about 50 feet from the road, in what would today be the 9500 block, approximately at Black Mountain Road, looking north. Commercial development has since filled the immediate area. (BrS.)

COWS ON MIRA MESA. Looking south across the open rocky mesa toward El Camino Memorial Park (a sharp eye can notice El Camino's flag on the horizon behind the cows), this July 1971 photograph shows a herd of cattle contentedly grazing. Most of Mira Mesa once looked like this. The location of the photograph was west of the present-day intersection of Mira Mesa Boulevard and Camino Santa Fe. (BrS.)

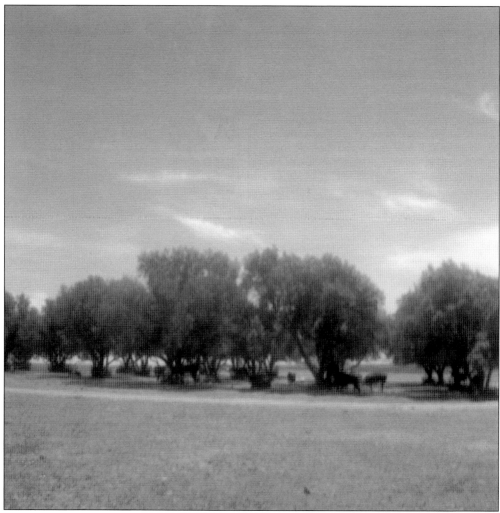

THE "OLIVE GROVE." This cluster of mature olive trees in western Mira Mesa was a local landmark for years, up until the 1983 opening of Mira Mesa Boulevard west to Interstate 805 and the commercial/industrial development that changed the look of the area and configuration of the grove but did not eliminate the trees. The developer of the industrial park along Flanders Drive, south of Mira Mesa Boulevard and west of Camino Santa Fe, used the trees in landscaping, keeping some in place and transplanting others within the area. For a view of the olive grove area today, see page 126. In this July 1971 photograph, cattle enjoy the shade of the trees. (BrS.)

Two

Affordable Homes—But Not Even a Grocery Store

When its first tract homes appeared in 1969, Mira Mesa grew so rapidly it soon became synonymous with unplanned growth. Pardee, Inc., named its first subdivision Mira Mesa Verde (meaning "view of the green mesa" in Spanish), which became shortened to Mira Mesa ("view of the mesa") as a name for the new community. The only way to get into or out of the community was via Highway 395, which is now Interstate 15, then via the two-lane Mira Mesa Boulevard that at first only extended west as far as Westmore Road.

The homes were affordable, and young families were delighted that they could actually buy them. However, residents moving into Mira Mesa from 1969 through 1972 found that other than the houses, there was little else there—not even a grocery store! Construction began for Bradshaw's, the first market in Mira Mesa, which opened in mid-1971, but for the next few years it was all there was. When Joan Stranger moved to Mira Mesa in May 1972, there was "one market, one gas station, and a bank in a trailer!"

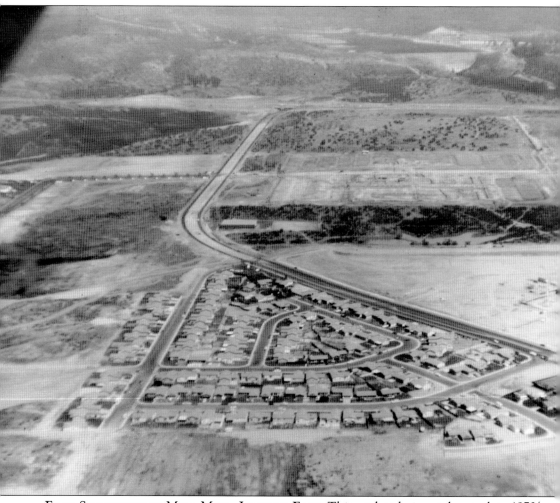

FIRST SUBDIVISION IN MIRA MESA, LOOKING EAST. This undated view, taken in late 1970/early 1971, looks east over the triangular Mira Mesa Verde, Unit No. 1, the first subdivision in Mira Mesa. Mira Mesa Boulevard is visible in the middle, extending down (westward) from the bridge overcrossing for Interstate 15/old Highway 395 in the distance, then curving to the right (southwest). Bradshaw's Market is under construction in the future shopping center on the south side of Mira Mesa Boulevard. Developed by Pardee, Inc., this one-year-old neighborhood lies north of Mira Mesa Boulevard between Westmore Road and Greenford Drive. Westmore Road takes off below Mira Mesa Boulevard in the center of the photograph, just to the right of where Mira Mesa Boulevard curves southwest. The bare ground at the northeast corner of Westmore Road and Mira Mesa Boulevard is the current site of Christ the Cornerstone Lutheran Church and School. The temporary Mira Mesa Elementary School is at the lower right. Lake Miramar, a city reservoir in nearby Scripps Ranch, is at the upper right. (MM.)

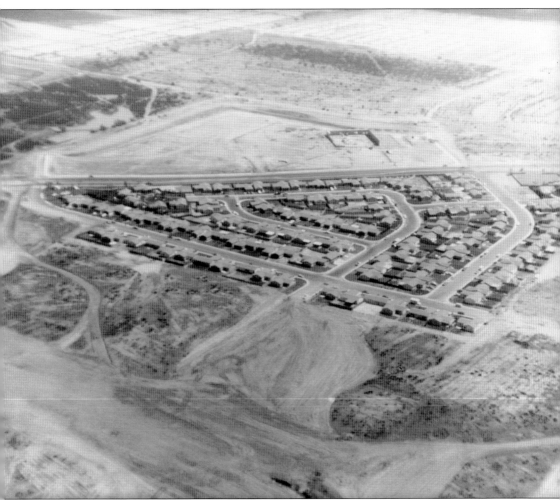

MIRA MESA VERDE, UNIT NO. 1, LOOKING SOUTH. This view of the first subdivision in Mira Mesa, from late 1970/early 1971, looks south toward Mira Mesa Boulevard, which extends from east to west across the center of the photograph. The walls for Bradshaw's, the first market in Mira Mesa, are clearly visible toward the right of the developing shopping center south of Mira Mesa Boulevard. Donald Suycott, who moved into his newly built home at 8955 Westmore Road in October 1969, said his house was the "tenth house in Mira Mesa" and he was the sixth homeowner to move in. At the time, Mira Mesa Boulevard was a two-lane road ending at Westmore. There was no gas station, no drugstore, and no supermarket. "Everyone had to go to Poway or Clairemont for everything," Suycott recalled. Nobody had telephones the first few months, so Suycott and other early residents used the pay phone in the parking lot at Pardee, Inc.'s, model homes then at Westmore Road and Mira Mesa Boulevard. (MM.)

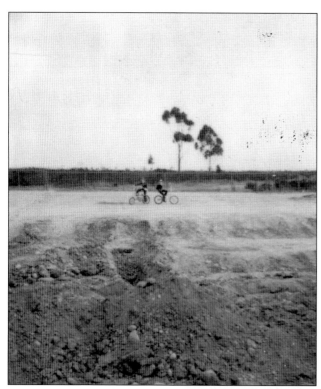

BERNARD SENICK RESIDENCE, MARCH 1974. Mira Mesa resident Bernard Senick, who taught at Mason Elementary School in Mira Mesa until his retirement, documented the construction of his house a block west of Camino Ruiz on Jade Coast Drive from March 1974 until completed in October 1974. At left and below, the house can be seen before the start of construction and following digging trenches for pouring the slab. Homes had been built by 1974 in the area around Lowell Mason Elementary School at Gold Coast Drive and San Ramon Drive, sending students at first to temporary "schools in houses" (see chapter three) and then to portables on the future Mason site starting in the 1973–1974 school year. (Both BS.)

BERNARD SENICK RESIDENCE, EARLY SUMMER 1974. In the photograph at right, the slab had just been poured for Bernard Senick's home on Jade Coast Drive. Below, the boards for the outer walls had been put up. Senick was already living in Mira Mesa at another location at the time. Like Donald Suycott, Senick said that during the early 1970s in Mira Mesa there was a lack of community facilities but a certain pioneer spirit and camaraderie among neighbors. "People were friendly. They had a welcome block party for all the people moving in," Suycott said. (Both BS.)

BERNARD SENICK RESIDENCE, LATE SUMMER 1974. Above, Bernard Senick's house is fully framed; below, the walls are completed. Senick and Suycott were among many early Mira Mesa residents who mentioned affordable homes were a major attraction of Mira Mesa. Suycott purchased his home on Westmore Road for $18,950. "We bought our house in 1971 and the coyotes and rabbits used to come on the lawn," said Pat DeLozier-Dexter. Located on Baywood Avenue and Flanders Drive, at the time they bought their house "there was no Village across the street." The Village, a condominium complex featuring inward-facing units in a park-like setting, was built not long afterward. "With four children, who would rent to us? We chose Mira Mesa because we could afford to buy there," DeLozier-Dexter said. (Both BS.)

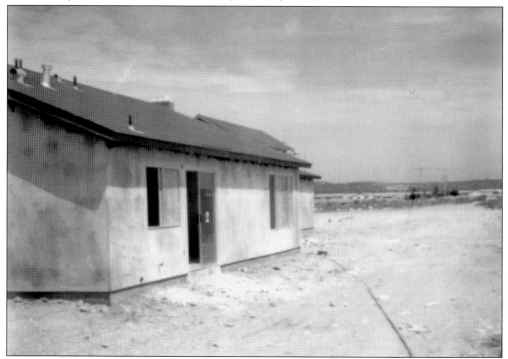

BERNARD SENICK RESIDENCE, OCTOBER 1974. Pictured at right, Bernard Senick's house is almost complete. In the photograph below, the house is shown in October 1974 complete and ready for move-in, even including a young tree planted in the front yard. Senick has enjoyed being a Mira Mesa resident through the years and still lives in the same house today. Suycott is also still a Mira Mesa resident, although no longer on Westmore Road. After three years there, Suycott bought a condo in The Village, on Caminito Vera "on the park," where he lived until 1981 when he bought a "Parkdale" model home on Gold Coast Drive in southwest Mira Mesa. "Some areas could have been planned a little better," Suycott said, but he appreciates Mira Mesa. "I've enjoyed living here," he said. (Both BS.)

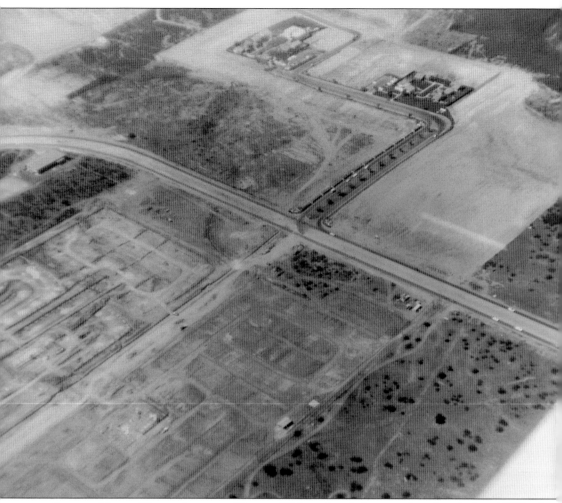

LARWIN MODEL HOMES, LOOKING NORTH. This undated photograph, taken in late 1970/early 1971, shows the Larwin Company model homes off Black Mountain Road on Gemini Avenue for their developments in northern Mira Mesa. At the time, the recently built "new" Black Mountain Road only extended a short distance north from Mira Mesa Boulevard, curving left (west) onto Gemini Avenue. The original Pardee, Inc., subdivisions were all single-story homes. Larwin offered both one-story and a number of two-story models. Many of the Larwin homes were in neighborhoods where those who purchased homes also gained access to a swimming pool in a private park-like setting within the neighborhood, maintained by a homeowners' association. Kay and Bill Morrow moved into their Larwin home on Bootes Street in December 1971, the second ones on their block. The five-bedroom Spacemaster model they purchased had sold for $19,000 "unfinished" when it was originally offered in 1969, but they paid $34,000 for their new home in 1971, Kay said, both because homes had been appreciating about $1,000 per month and in order to get it "finished" including extras such as a fireplace. (MM.)

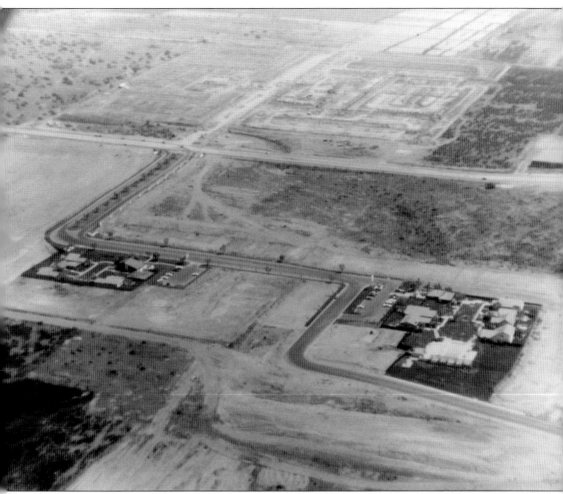

LARWIN MODEL HOMES, LOOKING SOUTH. This photograph, taken in late 1970/early 1971, looks south over the Larwin model homes toward Mira Mesa Boulevard. On the south of Mira Mesa Boulevard, grading can be seen in preparation for the senior mobile home park now on that site. When Kay and Bill Morrow moved into their home on Bootes Street in December 1971, Bradshaw's Market had recently opened, but it was the only store in that still undeveloped shopping center. The Morrow's children were teenagers who had to attend junior high and high school in Clairemont because Mira Mesa's first secondary school did not open until 1976. Still, Kay remembers with pleasure their backyard dropped off to a then wild canyon, with "a little stream that ran back there" and a variety of wildlife, and "it was so great the kids would walk the dog in the fields." (MM.)

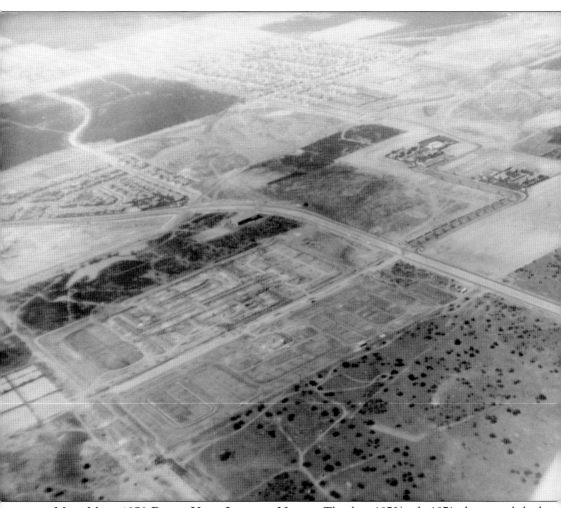

MIRA MESA 1970 BROAD VIEW, LOOKING NORTH. This late 1970/early 1971 photograph looks north across Mira Mesa Boulevard and shows both the original triangular Pardee neighborhood between Greenford Drive and Westmore Road and the Larwin model homes. A piece of the future Pegasus Way extends north to curve onto Libra Drive, which leads west (diagonally to the upper left in the photograph) to Westonhill Drive, where the outlines of additional development can be seen. Westmore Road extends west of Westonhill, curving through an area of undeveloped land that appears dark and brush-covered. South of Mira Mesa Boulevard, grading can be seen for development of the senior mobile home parks, The Woods, at the west side of Black Mountain Road, and The Village Green, at the east side of Black Mountain Road. The Mira Mesa post office was not yet built. Lee Dronick remembers in the early 1970s the post office used to be in a trailer near Miramar College, and a bookmobile stopped "across from the post office." (MM.)

HOURGLASS FIELD. Miramar College, a San Diego Community College district campus, began in 1969 on land originally called Hourglass Field, since it had been an auxiliary U.S. Navy landing field with outer boundaries shaped like an hourglass. The "hourglass" can be seen in approximately the center of this photograph, a close-up from a larger aerial photograph taken c. 1970. In 1941, the U.S. Navy acquired 170 acres from the San Diego Water Agency to build an airfield. The land was relinquished to civilian aircraft use after World War II. From 1957 to 1959, Hourglass Field was used by the California Sports Car Club and the San Diego Regional Sports Car Club of America. In 1965, the San Diego Unified School District, which at the time administered community colleges as well as kindergarten through twelfth-grade education, acquired Hourglass Field and the surrounding area from the U.S. Navy for free with the condition that an educational facility was built within 18 months. In 1969, what was to become Miramar College opened as a $1 million facility, the Miramar Regional Occupational Training Center, consisting of a main classroom building, fire training range, and police training range. The first faculty members hired were Terry Truitt and Jim Palmer. (BF/MMSC.)

Jack's Arco. This news photograph in the March 4, 1976, issue of the *Rancho Mesa News*, a weekly Mira Mesa community newspaper edited and published by Denise Stewart, shows Jack's Arco station. Jack's Arco, owned and operated by Jack O'Connor, was the first gas station in Mira Mesa, according to Stewart, who together with her husband and sons lived in Mira Mesa from December 1971 until 1991. (S.)

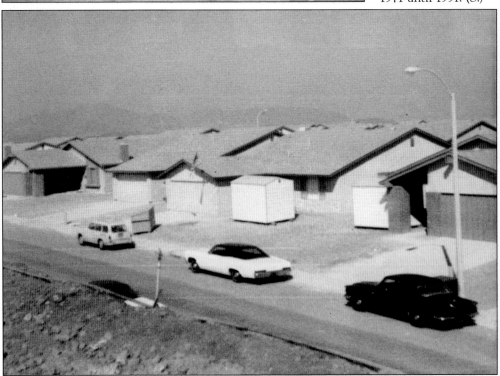

Avenida del Gato, 1971. This row of newly built houses on Avenida del Gato, across the street from the future Sandburg Elementary School, is typical of Mira Mesa at the time and also shows several of the houses that were the temporary North Mira Mesa Annex school that opened in 1971. Four homes—11229, 11235 (right, just past light pole), 11241 (house with flag), and 11247 Avenida del Gato—were made available to the school district by the Larwin Company. See chapter three for more details. (S.)

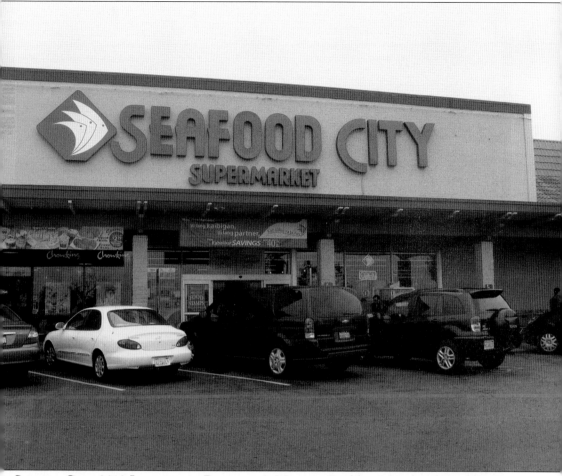

SEAFOOD CITY, 2010 LOCATION OF BRADSHAW'S MARKET. Bradshaw's Market, located in the shopping center south of Mira Mesa Boulevard between Greenford Drive and Westmore Road/ Marbury Avenue, was the first grocery store in Mira Mesa, opening in mid-1971. It did not last long, perhaps because, as Denise Stewart said, its prices were too expensive for a family with young children on a budget so "we went to Kearny Mesa or Poway to shop." By 1975, Bradshaw's was no longer there and the store had become an Alpha Beta. It remained Alpha Beta through the 1980s, became Lucky's in the 1990s, then Albertsons in 2000. After the Mira Mesa Market Center opened in August 2000 on Westview Parkway with a new Albertsons, their former location was phased out. In a reflection of Mira Mesa's growing Asian population, the store became Seafood City, an Asian supermarket that sells not only fish but a variety of items. Through the years the area behind the market, whatever its name, has been the traditional line-up location for the Mira Mesa Fourth of July parade. (PJS.)

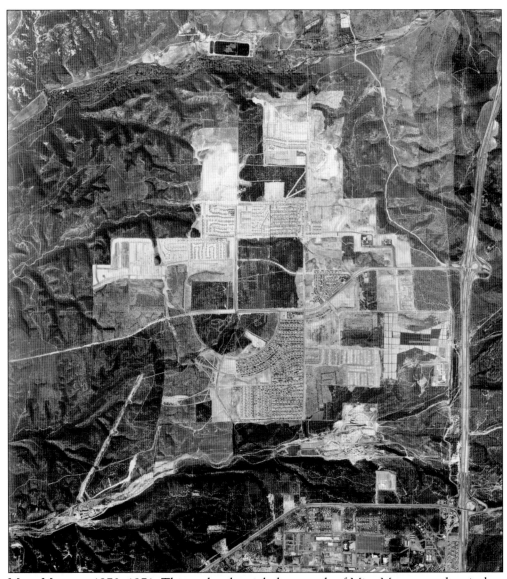

MIRA MESA, C. 1970–1971. This undated aerial photograph of Mira Mesa was taken in late 1970/early 1971 and shows both how rapidly Mira Mesa grew since the first tract homes were built in 1969 and also how much of the community was yet to be developed. At the present-day "crossroads" of Mira Mesa at Mira Mesa Boulevard and Camino Ruiz, none of the four corners have yet been developed: no Mira Mesa Mall on the northwest, no retail/office mall/medical mall on the northeast, no Mira Mesa High School on the southeast, and no Target Center on the southwest. Mira Mesa Boulevard extends west to Montongo Street, continuing afterward as a dirt road. Camino Ruiz only extends north from Mira Mesa Boulevard, not south. Westmore Road curves across the undeveloped area, extending west to cross Camino Ruiz and Reagan Road, ending at Montongo Street and providing access to homes developed along Avenida del Gato. (BF/MMSC.)

Three
SCHOOLS COME TO MIRA MESA

Much of Mira Mesa's history is the history of its schools, including the unique experience in the early 1970s of the "schools in houses" that provided the new community's first local elementary schools within tract homes leased from developers. Portables on future elementary school sites provided another option starting in 1971, although some of the schools in houses were still in operation.

Neither the schools in houses nor the portables kept pace with Mira Mesa's population growth. Denise Stewart, who moved to Mira Mesa in December 1971, and Judy Parker, who came in early 1972, both moved into homes in the North Mira Mesa Elementary School (future Ericson Elementary School) neighborhood and said their sons had to start kindergarten in Clairemont. Their experience was typical. For teens, there was no local secondary school until Mira Mesa Junior/Senior High opened in 1976, so parents had to drive them to junior high or high school in Clairemont.

Mira Mesa residents held Marches for Schools and lobbied for permanent local schools, even considering setting up a Mira Mesa School District. The Mira Mesa Town Council, Mira Mesa's nonprofit civic group, organized walks and supported the effort. Mira Mesans for Schools formed specifically to focus on the schools cause. Sandra Archer (formerly Sparks) remembers "walking with an infant in a stroller for the bond issue that got us the schools."

In November 1974, a school bond passed within the city of San Diego, funding new schools in Mira Mesa. Five elementary schools—Sandburg, Mason, Walker, Ericson, and Hickman—and Mira Mesa Junior/Senior High School all were built and opened in 1976. In addition, the temporary Ellen R. Breen Elementary School for grades kindergarten through third opened in 1976 and operated until 1990, when Hage Elementary School opened. Wangenheim Junior High School, which is now a middle school, came along in 1978, and Challenger Junior High School, also now a middle school, opened in 1987 as a temporary facility in portables and in 1990 as a permanent campus.

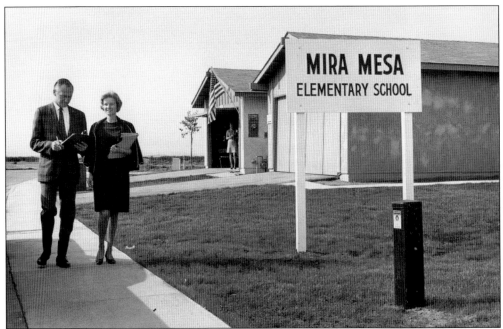

MIRA MESA ELEMENTARY SCHOOL, EXTERIOR AND INTERIOR. When Mira Mesa's first tract homes were built in 1969, families flocked to the affordable housing but found there were no schools or other local services. Both of these photographs were taken on December 1, 1969, when the temporary Mira Mesa Elementary School opened inside two houses on Harlington Drive leased from the developer, Pardee, Inc., becoming the first school in the new community. The photograph above shows the exterior of the houses, looking toward Buckhurst Avenue. Inside, the houses had some interior walls removed to create more room for classes. Below is a classroom scene. The school had Herman M. Berner (aka "Bill" Berner) as principal, three teachers, a school secretary, a custodian, and 23 students. It was a homey setting. By May 1970, the complex had expanded to 180 children, grades K–6, in four houses. (Both SDUSD.)

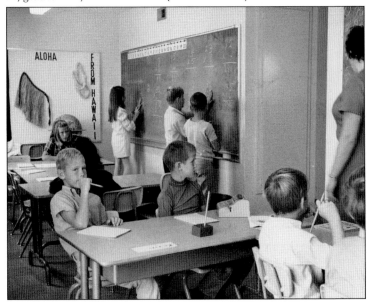

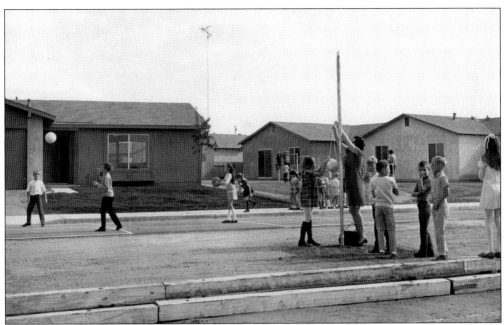

MIRA MESA ELEMENTARY SCHOOL, SIDE VIEW AND PRINCIPAL'S OFFICE. Taken on December 1, 1969, the photograph above shows students playing outside the first school in Mira Mesa the day classes began in tract houses leased from the developer, Pardee, Inc., on Harlington Drive at Buckhurst Avenue. The students are playing on a section of Buckhurst Avenue blocked for a playground behind the two Harlington Drive houses. The photograph below shows the path to the principal's office, located inside one of the houses. Additional temporary schools in houses followed as Mira Mesa's population surged in the early 1970s. According to statistics in the 2008–2009 annual report for Miramar College, which also began in 1969, the population of Mira Mesa in 1970 was 1,180 and the population of Scripps Ranch was 509. In 1975, the combined population of Mira Mesa and Scripps Ranch was 27,000. (Both SDUSD.)

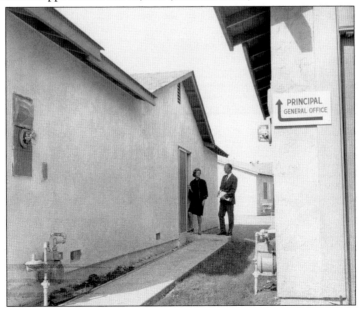

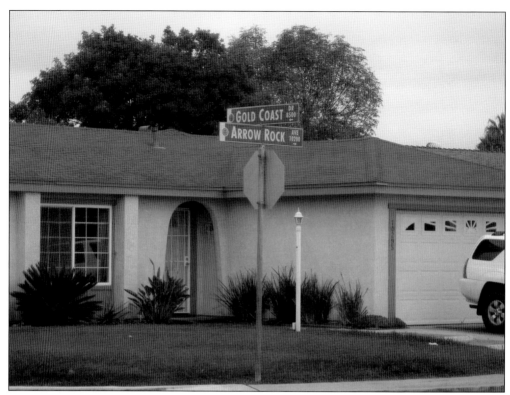

MASON ELEMENTARY SCHOOL'S EARLY DAYS. Students living in Mira Mesa near today's Lowell Mason Elementary School at Gold Coast and San Ramon Drives attended the temporary school at Harlington Drive and Buckhurst Avenue from December 1, 1969, through the 1969–1970 school year. In September 1970, a temporary school opened for the Mason area in four Pardee houses at the corner of Arrow Rock Avenue and Gold Coast Drive, across the street from the future Mason campus. The photograph above, taken in October 2010, shows the southeast corner where Mira Mesa resident Judy Taylor says two houses were used for a temporary school during the 1972–1973 school year when her son attended kindergarten there. "His class was in the living room, and there was a first grade class in one bedroom," Taylor said. The next year, in 1973–1974, Taylor's son went to first grade and her daughter started kindergarten in the bungalows set up on the Mason site until the permanent school, pictured below, opened in 1976. (Both PJS.)

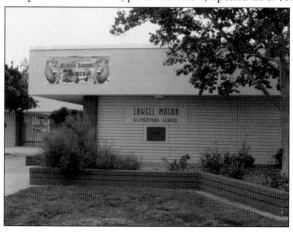

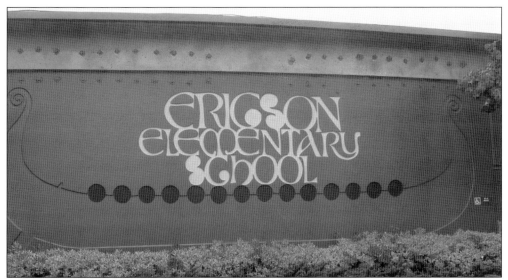

NORTH MIRA MESA ELEMENTARY SCHOOL. Leif Ericson Elementary School began as a temporary, all-portables school, North Mira Mesa Elementary School, which opened on February 23, 1971, in eight portable buildings on the north end of the future Ericson Elementary School site at 11174 Westonhill Drive, with 129 children and eight staff members. The Larwin Company paid for the expense of moving the portables, along with site grading, providing utilities, and building a toilet building. Herman M. "Bill" Berner was the principal who opened the all-portables school. Bernadine "Birdie" Fuhrman became principal shortly afterwards. Above is a photograph of Ericson Elementary School in October 2010. Below is a contemporary photograph of Bernadine Fuhrman, at right, together with several original Ericson/North Mira Mesa Elementary School faculty members. Pictured are, from left to right, (first row) Marge Gould and Bernadine Fuhrman; (second row) Cathy Doss and Bill Stallo. (Above PJS; below GF.)

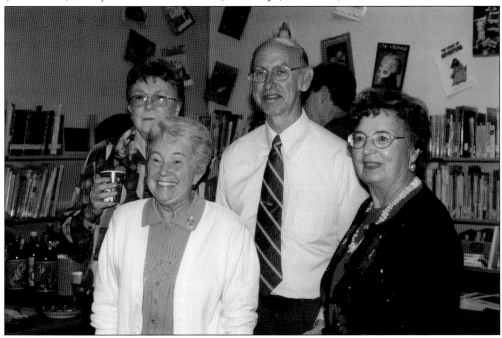

MESA VIKING PARK. Mira Mesa resident Bill Stallo taught at North Mira Mesa/Leif Ericson Elementary School from the time the portables opened until his retirement. Stallo said his "first memories are of going there and seeing partially completed streets everywhere." Mesa Viking Park, on the west side of Westonhill Drive immediately south of the school, seen above in a photograph from October 2010, was a brush-covered, vacant lot in 1971. Local residents complained about the public safety hazard of periodic brush fires and urged the city to develop the park. (PJS.)

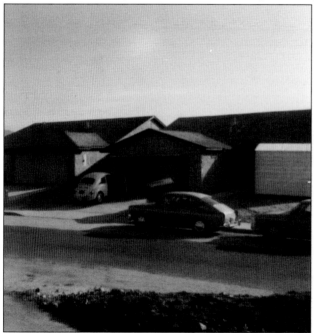

NORTH MIRA MESA ELEMENTARY SCHOOL ANNEX, 1971. This 1971 photograph shows one of the four houses on Avenida del Gato that was the North Mira Mesa Elementary School Annex, the future Carl Sandburg Elementary School. The location was across the street from the current Sandburg campus. Bernadine Fuhrman was principal of both this school in houses and the all-portables North Mira Mesa Elementary School, dividing her time between the two locations by making her way from one to the other on dirt roads. Two hundred students attended the school in eight classrooms spread among the four houses. (S.)

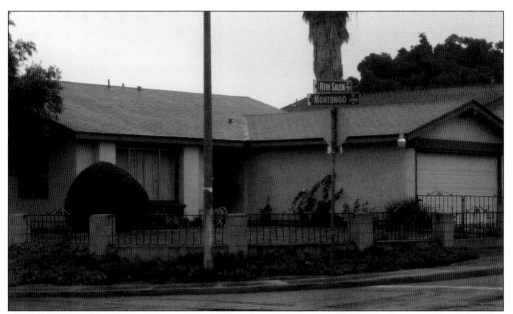

HICKMAN ELEMENTARY SCHOOL'S EARLY DAYS. This present-day photograph shows the southwest corner of Montongo and New Salem Streets, the site of the school in houses donated in November 1971 by Pardee, Inc. Five new Pardee houses, containing nine classrooms, a teacher's workstation, and playground equipment, were provided rent-free to the San Diego Unified School District. The houses were on New Salem Street immediately north of the future Hickman Elementary School (then called Miramar Elementary School) site on Montongo Street. (PJS.)

MARCH FOR SCHOOLS. In May 1972, a March for Schools organized by the Mira Mesa Town Council was held to protest Mira Mesa's continuing and growing critical need for more classrooms and permanent schools. This walk was among the first of many grassroots efforts that led ultimately to the successful school bond in 1974. The march left from North Mira Mesa Elementary School (the future Leif Ericson Elementary School) and concluded at the Larwin model homes on Gemini Avenue. North Mira Mesa Elementary School was so full by January 1972 that the 560 students were on double session, and 107 other children were transported at parents' expense to Clairemont schools. The present-day picture above shows one of Ericson Elementary School's portables augmenting its permanent buildings. (PJS.)

WALKER ELEMENTARY SCHOOL OPENS. Mary Chase Walker Elementary School, located on Hillery Drive at Black Mountain Road, opened on October 16, 1972, with three "six pack" portable classroom buildings. Students from the Walker neighborhood had previously attended school at "Mason Annex 1 in houses on Harlington Avenue," according to a *Mira Mesa Times* article from October 11, 1972. The original Walker staff consisted of 10 teachers led by principal Herman M. "Bill" Berner. Nine regular portable buildings and one bathroom building were provided by the district as Walker Elementary School's enrollment grew. Pictured above, the October 1972 *Mira Mesa Times* news photograph from the Walker Elementary School archive shows the portables and playground equipment. The photograph below shows Walker Elementary School today; it was the fourth of six Mira Mesa schools that opened in 1976. (Above, W.; below, PJS.)

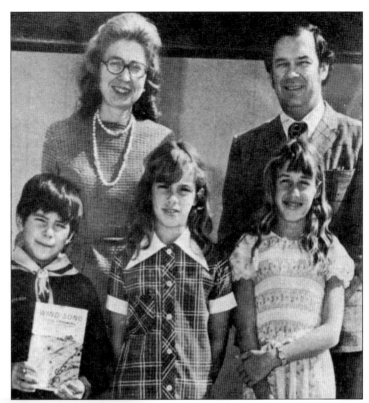

SANDBURG ELEMENTARY SCHOOL NAMING CEREMONY. Carl Sandburg Elementary School was named after the poet by a vote of students while classes were still being held in the houses on Avenida del Gato. Pictured in this 1972 news photograph from the Sandburg Elementary School archive are, from left to right (first row), students Gabriel Smith, Lisa Wren, and Barbara Zepik; (second row), principal Dr. Rosary Nepi and teacher Donald Hensley. Nepi was also the principal of Hickman Elementary School. (S.)

ERICSON PRINCIPALS THROUGH THE YEARS. Shown in this c. 2007 photograph, Bernadine Fuhrman (seated, center) was principal of North Mira Mesa Elementary School in 1972 when it was renamed Leif Ericson Elementary School after the famous Norse explorer. Fuhrman continued as Ericson's principal through the opening of the permanent school facilities in 1976 until her retirement in 1980. Also shown are succeeding Ericson Elementary School principals, from left to right, Stewart Brown, Dr. Gail Guth, and Linette daRosa, along with longtime Ericson teacher Bill Stallo, who is now retired. (BJP.)

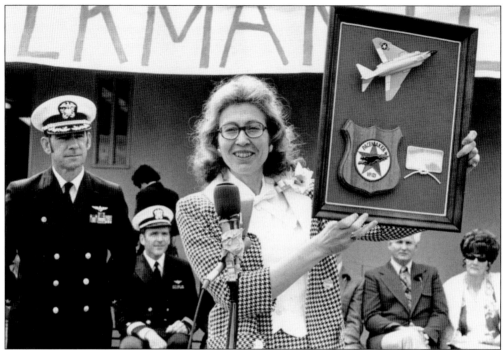

HICKMAN ELEMENTARY SCHOOL NAMED. In the March 1973 photograph above, Dr. Rosary Nepi, principal of Albert Joe Hickman Elementary School, displays the plaque she accepted on behalf of the school from Fighter Squadron 121 (VF-121) during the school's naming ceremony. The story of pilot Albert Joe Hickman's self-sacrifice to save a school inspires Hickman students to this day. On December 4, 1959, when his plane went out of control while returning to Naval Air Station Miramar, Ensign Hickman elected to remain with his craft to steer clear of a populated area including Hawthorne Elementary School in Clairemont, losing his life in the ensuing crash. Standing with Nepi is commanding officer Comdr. Russell Davis; seated are former prisoner of war Lt. Comdr. Dennis A. Moore and relatives of the late Ensign Hickman. The permanent Hickman campus buildings seen below in this October 2010 photograph were constructed in 1976. (Above, H.; below, PJS.)

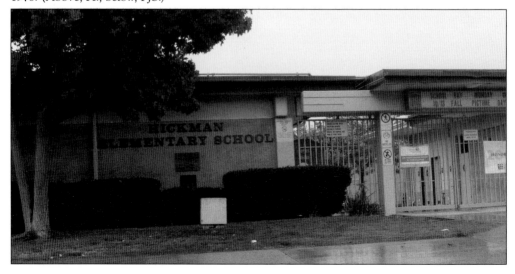

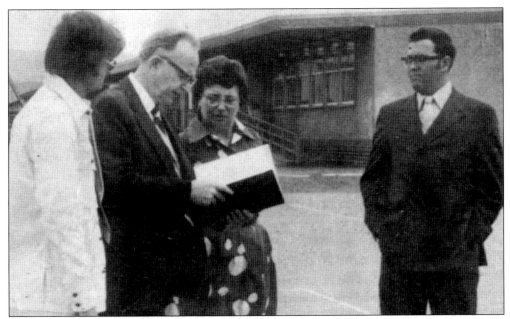

MIRA MESANS PETITION FOR OWN SCHOOL DISTRICT. In June 1973, Mira Mesa residents filed a petition to separate from the San Diego Unified School District and form their own local district. Residents were concerned there were still no definite plans to build permanent school facilities, and the district's option to buy the future school site land where portable buildings were located would expire in December 1973. Pictured above in a June 20, 1973, *Mira Mesa Times* photograph, from left to right, are Phil Henry, chief petitioner for the formation of the Mira Mesa Unified School District; Loren A. Wann, field representative for the California State Board of Education; Bernadine Fuhrman, principal of Ericson Elementary School; and chief petitioner Hal Shwartz. (S.)

SANDBURG STUDENTS' MOVING DAY. In November 1973, Sandburg Elementary School students said goodbye to their temporary school in the houses on Avenida del Gato and moved across the street to new portable classrooms on the future Sandburg campus. Pictured above in this local news photograph from the Sandburg Elementary School archive is one of the portable classrooms. (S.)

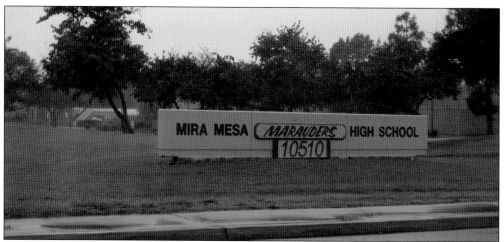

MIRA MESA GAINS PERMANENT SCHOOLS, 1976. A successful November 1974 school bond resulted in the construction and opening in 1976 of five elementary schools in Mira Mesa—Sandburg, Mason, Walker, Ericson, and Hickman—as well as Mira Mesa Junior/Senior High School. In this October 2010 photograph of Mira Mesa High School, the sign with the name of the school mascot, the Marauders, covers up the portion of the engraved letters on the concrete monument that spell "Junior," reflecting the school's original seventh through twelfth grade configuration. (PJS.)

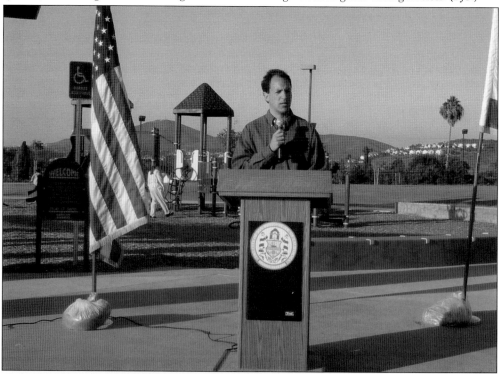

BREEN K-3 TEMPORARY SCHOOL SITE NOW A PARK. In September 1976, the Ellen R. Breen School opened on Polaris Drive as an all-portables kindergarten through third grade temporary school. Breen was closed when Hage Elementary School on Galvin Avenue opened in 1990, and the site was purchased for a park by the City of San Diego. Pictured is city councilman Brian Maienschein at the Breen Park opening ceremony in 2005. (PJS.)

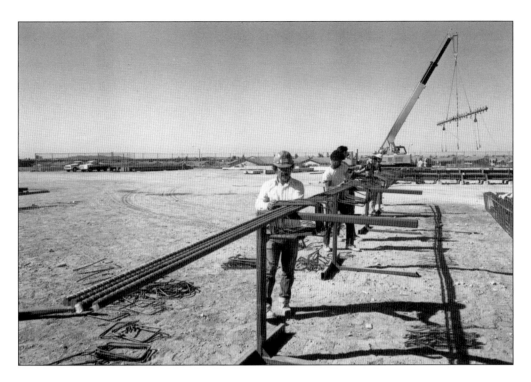

SANDBURG ELEMENTARY SCHOOL CONSTRUCTION, PHASE ONE. These photographs, courtesy the Sandburg Elementary School archives, begin a sequence showing the construction of the permanent school buildings. Above, construction workers carry a beam. Below, pillars are rising. (Both S.)

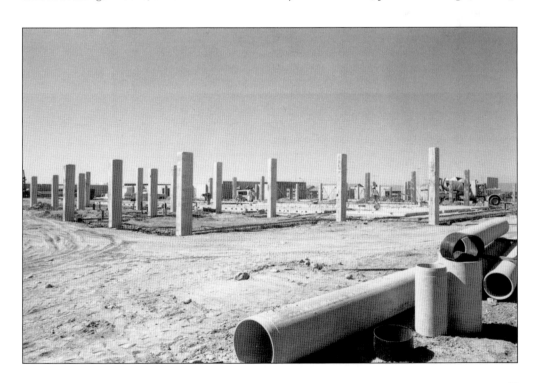

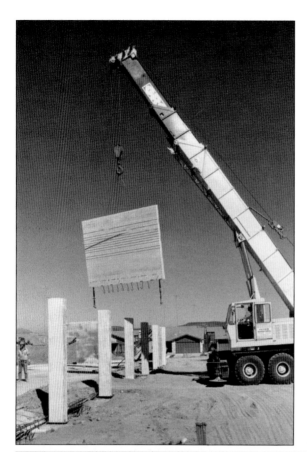

SANDBURG ELEMENTARY SCHOOL CONSTRUCTION, PHASE TWO. These photographs continue the sequence documenting the construction of Sandburg Elementary School. Pictured at left, a crane lifts a wall into place, and pictured below, several more walls take shape. (Both S.)

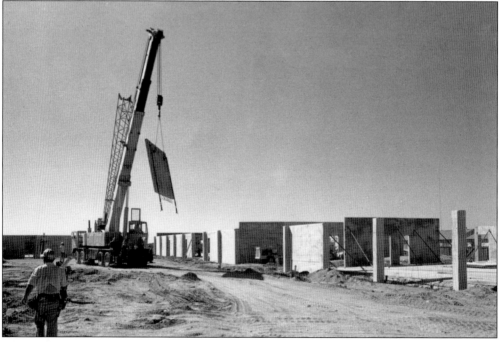

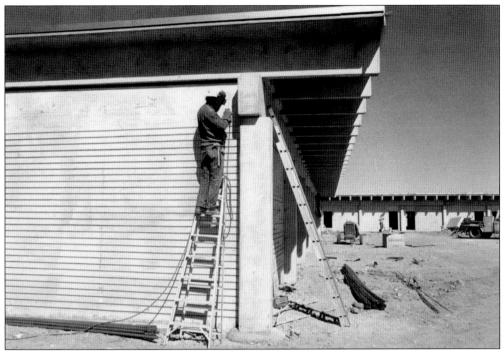

SANDBURG ELEMENTARY SCHOOL CONSTRUCTION, PHASE THREE. Concluding the sequence of photographs showing Sandburg Elementary School under construction, the photograph above shows a construction worker putting finishing touches on one of the buildings. Shown below, the new school is ready to open. (Both S.)

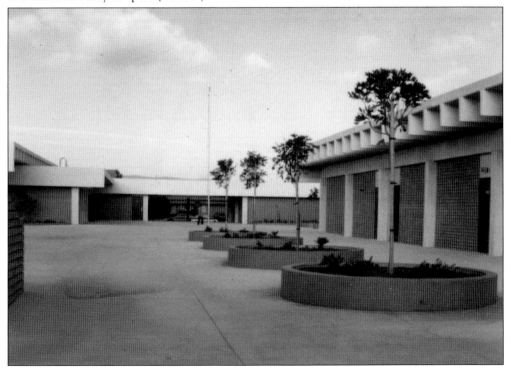

SANDBURG ELEMENTARY SCHOOL, 2010. This October 2010 photograph of the courtyard at Sandburg Elementary School, at 11230 Avenida del Gato, shows the lush foliage of trees growing since the school opened in 1976. In the foreground is a map of the United States painted on the quad. (PJS.)

AVENIDA DEL GATO, 2010. After classes moved out of the schools in houses, the houses had their interiors remodeled by developers Pardee and Larwin and were sold as residential homes. Like the other schools in houses locations at Harlington Drive and Buckhurst Avenue, Arrow Rock Avenue and Gold Coast Drive, or New Salem Street at Montongo Street, this house on Avenida del Gato across from Sandburg Elementary School looks much like the rest of its neighborhood. On a June day in 2010, it is a peaceful scene. Only a sense of history brings back the echoes of schoolchildren who once attended classes on that side of the street. (PJS.)

Four
"I Love Mira Mesa"

Mira Mesa's community groups grew along with the development of local shopping, schools, parks, and other recreation. One of Mira Mesa's first local recreation venues was the northeast Mira Mesa ice skating rink built in the early 1970s, then called House of Ice, now San Diego Ice Arena. Walker Scott Department Store, Mira Mesa's first such business, opened in February 1975, as did Vons supermarket. Newberry's variety store and other Mira Mesa Mall shops all came soon. In 1975, Terry Tibbitts, a psychologist; John Worthington, a minister; and Andy Patapow, a school principal, created the family and youth social services nonprofit agency Harmonium, Inc. Local businesses Mandarin Garden Chinese restaurant, at the Mira Mesa Mall since 1976, and Callahan's Pub & Brewery, a microbrewery and family restaurant established in 1989 at the Mira Mesa Mall and now at the Target Center, became an active part of the community.

The Mira Mesa Town Council, Mira Mesa's nonprofit volunteer civic group, joined forces with the Mira Mesa Mall to organize annual I Love Mira Mesa Day celebrations starting in 1976. The Mira Mesa Woman's Club was founded in the 1970s, as was the Mira Mesa Junior Women's Club. Fourth of July celebrations were organized by a volunteer Mira Mesa Town Council committee. The first Mira Mesa Branch Library opened in 1977 in a building that is now the Epicentre teen center. As opportunities to do things within the community grew, so did a local sense of identity and hometown pride.

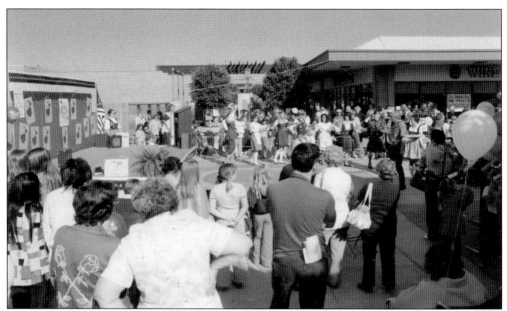

I LOVE MIRA MESA DAY 1977. As schools and stores were built, a new community spirit started to develop in Mira Mesa. The Mira Mesa Town Council was incorporated in 1972 to "promote and provide the civic, cultural, social, and recreational improvement of Mira Mesa." The Mira Mesa Town Council, together with the Mira Mesa Mall, held the second annual I Love Mira Mesa Day in 1977. The photograph above shows the community gathered around the stage in the center of the mall; below is the Mira Mesa Town Council table. I Love Mira Mesa Day was started in part to counter a reputation as an unplanned community with no stores or public facilities. For example, in his campaign for mayor in fall 1971, Pete Wilson famously used the phrase "no more Mira Mesas" to refer to this lack of community planning. By this time, however, public facilities and amenities were rapidly being developed. (Both JP.)

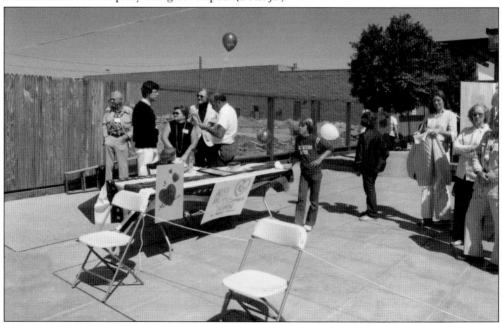

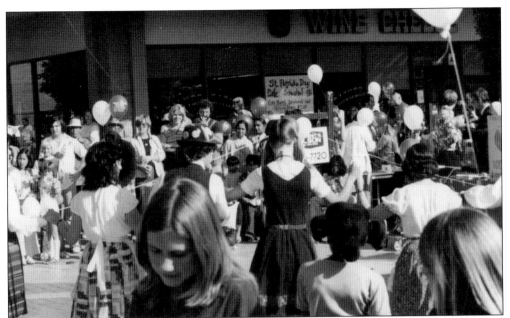

CELEBRATION AT THE MIRA MESA MALL. During the 1970s and 1980s, the centrally located Mira Mesa Mall was a focal point for the Mira Mesa community and served as the location for many community events, including the 1977 I Love Mira Mesa Day celebration shown here in front of the Cracker Barrel. (JP).

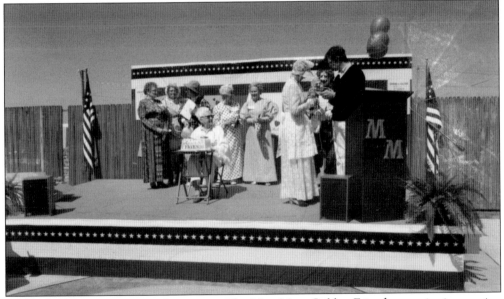

GOLDEN FRIENDS IN CLASSIC COSTUMES. The Mira Mesa Golden Friends organization serving Mira Mesa seniors was formed in 1977. Women from the Golden Friends are shown here in period costumes at the 1977 I Love Mira Mesa Day. The Golden Friends have been a very active organization in Mira Mesa through the years. In the 1980s, the group worked together with the North County Filipino–American Services (Fil-Am) to build a senior citizens recreation building. Later the Fil-Am partner organization in the senior center building changed to FASCA, the Filipino-American Senior Citizens Association. (JP.)

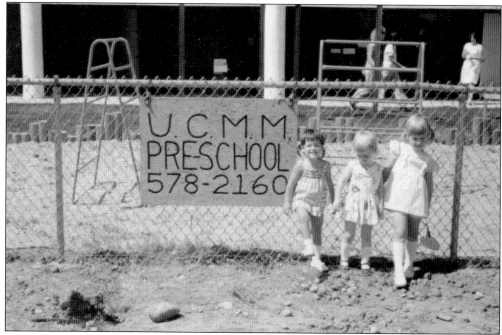

UNITED CHURCH OF MIRA MESA PRESCHOOL (UCMM). In addition to public schools, a number of preschools, private schools, and churches developed in Mira Mesa during the 1970s and 1980s. The United Church of Mira Mesa (UCMM) preschool was very popular and always had a long waiting list of young applicants. Shown in this photograph taken September 11, 1979, are, from left to right, Shannon and Sarah McCollum, both age three, and Nikole McCollum, age five. (SMM.)

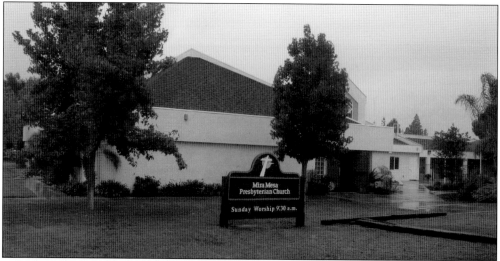

MIRA MESA PRESBYTERIAN CHURCH. The Mira Mesa Presbyterian Church, formerly the United Church of Mira Mesa, is shown here in an October 2010 photograph. During the 1970s and 1980s, it was also used as the meeting place for a number of community organizations, including the Mira Mesa Town Council and the Mira Mesa Junior Women's Club. The church was organized in 1973 by the Reverend John Worthington. The building now used for church education was completed in 1977, and the current sanctuary was completed in 1983. (PJS.)

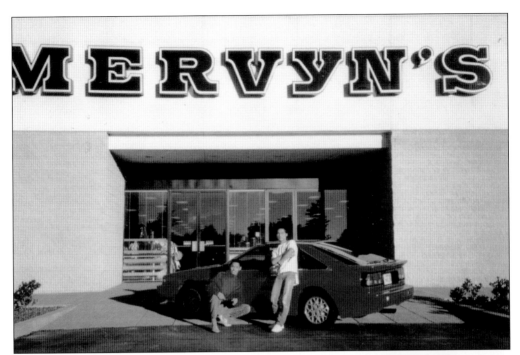

MERVYN'S IN 1986. The first major department store in Mira Mesa was Walker Scott Deparment Store, which opened on February 28, 1975, with Ronald Ellsworth as store manager. Ellsworth's wife, Charlene, recalls moving to Mira Mesa in order for Ron to open the store, and she quickly became active in the community. Charlene was one of the original members of the Mira Mesa Fourth of July Committee. In the early 1980s, the Walker Scott store was replaced by Mervyn's, shown here in 1986 with a car on its doorstep, together with Marlon Austria (left) and Gerry Guevara. Mervyn's was replaced in 2009 by a Kohl's department store. (MA.)

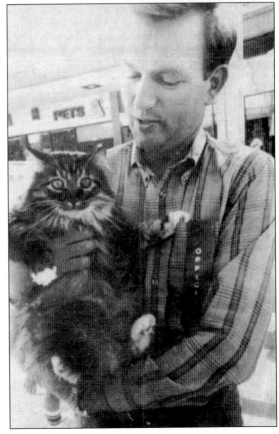

CITY COUNCILMAN ED STRUIKSMA. Shown here holding a 16 pound cat during a July 1983 pet show at the Mira Mesa Mall sponsored by the Mira Mesa Junior Women's Club and That Fish Store, Ed Struiksma represented Mira Mesa on the San Diego City Council from 1982 to 1990. He was a resident of Mira Mesa and frequently participated in community events. (PJS.)

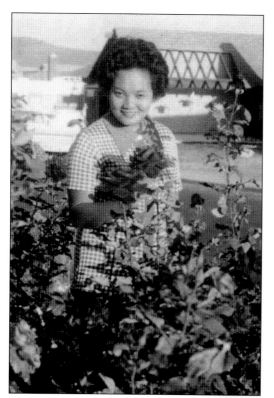

FAUSTA AUSTRIA. Mira Mesa's Filipino American population grew during the 1970s and 1980s. This picture from 1973 shows Fausta Austria in Mira Mesa near the corner of Alkaid and Menkar, visiting relatives who lived in Mira Mesa at the time. Originally from the Philippines, Fausta Austria made her home in Mira Mesa from 1978 on. Her daughter, Olivia, graduated from Mira Mesa High School in 1980 and her son, Marlon, graduated in 1985. (MA.)

MARLON AND OLIVIA AUSTRIA. This picture shows Olivia Austria, who was Miss Mira Mesa in 1983, and her brother, Marlon Austria, together with their mother, Fausta Austria, in front of their house on Ganesta Road in 1984. Marlon Austria is among the second generation of Mira Mesans who grew up in the community and now live in Mira Mesa as an adult. He and his wife, Brandi Oyos-Austria, live in the Pacific Ridge development in northwest Mira Mesa. (MA.)

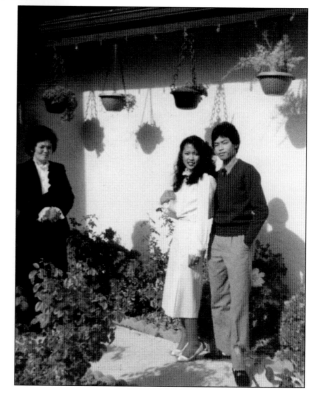

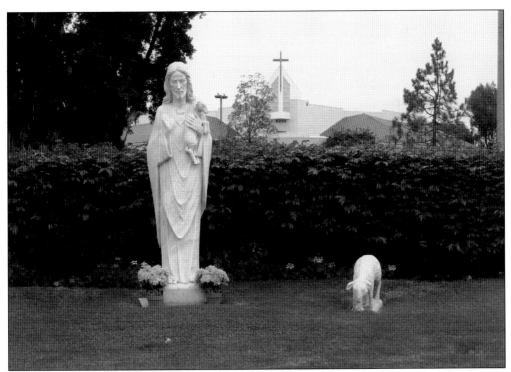

CHURCHES IN MIRA MESA. Churches developed in Mira Mesa during the 1970s and 1980s. Two of the largest are Good Shepherd Catholic Church at the corner of Gold Coast Drive and Camino Ruiz, with its iconic statues of Jesus and a lamb shown above, and the Church of Jesus Christ of Latter-Day Saints on Pegasus Avenue, shown below. Both churches have active congregations and are involved with the community. For many years, Good Shepherd Catholic Church's Oktoberfest was a Mira Mesa tradition. Good Shepherd Parish School serves kindergarten through eighth grade. (Both PJS.)

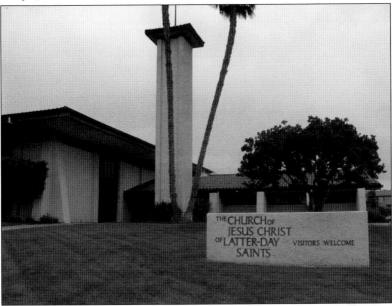

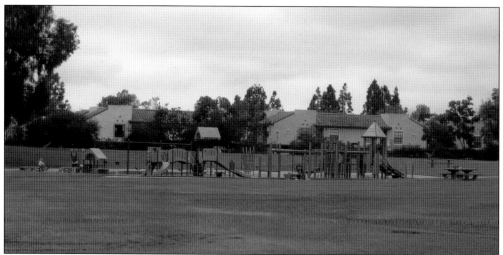

MESA VERDE PARK. One of the earliest parks in Mira Mesa is Mesa Verde Park on Gold Coast Drive west of Lowell Mason Elementary School. The park takes its name from that of Pardee, Inc.'s, original subdivision, Mira Mesa Verde. Along with the area off Westmore Road north of Mira Mesa Boulevard, homes near Mason Elementary School were among the first wave of development in Mira Mesa. Shown here in an October 2010 picture, Mesa Verde Park was the location of Fourth of July celebrations in the 1970s. (PJS.)

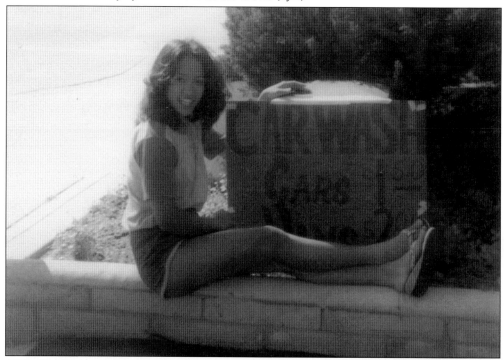

1980 CAR WASH AT JACK'S ARCO. Olivia Austria, then a Mira Mesa High School senior, brings people into Jack's Arco for a Mira Mesa High School Powder Puff fund-raising car wash in 1980. Jack's Arco was a full service gas station and automobile repair shop at the corner of Mira Mesa Boulevard and Black Mountain Road. Owner Jack O'Connor was an active participant in many Mira Mesa community groups and activities during the 1980s. (MA.)

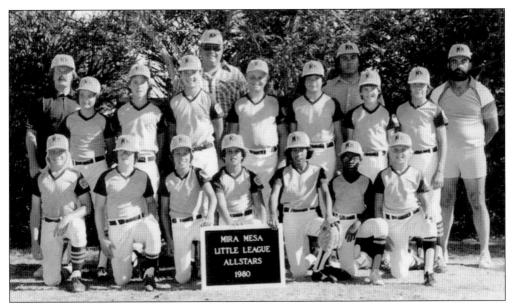

MIRA MESA LITTLE LEAGUE ALL-STARS. This 1980 picture shows the Mira Mesa Little League All-Star Team. Pictured are, from left to right, (first row) Robert Johnson, Robert Patterson, Shawn Moore, Willy Shipman, Marlon Austria, Essex Burton, and Jimmy Hall; (second row) Jon Willard, Dan Bozich, Smokey Freeman, Stephen Eicher, Tommy Hancock, Jimmy Pritikin, and Darrin Smith; (third row) coaches and assistants Marty Helsing, Ron Eicher, Victor Rico, and Bill Shipman. (MA.)

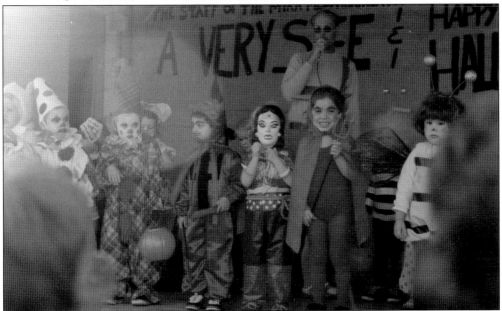

MIRA MESA HALLOWEEN CARNIVAL. The Mira Mesa Halloween Carnival has been a community tradition to provide safe and entertaining fun for youngsters since the late 1970s. This 1982 picture shows a costume contest that is part of this annual event. From the 1970s to the 1990s, the carnival was held at the Mira Mesa Mall. After remodeling reconfigured the mall, the carnival moved to the Mira Mesa Community Park and Recreation Center. (PJS.)

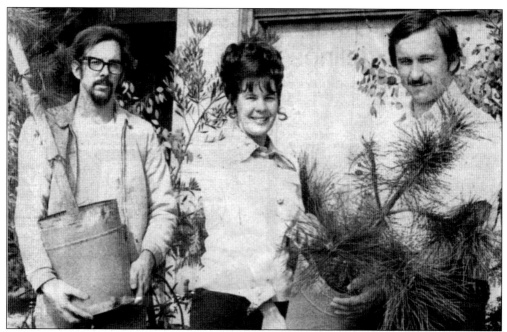

TREES FOR MIRA MESA. In 1975, the Mira Mesa Woman's Club received 30 trees as a donation from the Kiwanis Club, part of a successful Bicentennial beautification project organized by the Woman's Club to get 1,776 trees planted in Mira Mesa, either by individual homeowners or in public places. Charlene Ellsworth, Mira Mesa Woman's Club president, found homes for the 30 trees at three local churches—the United Church of Christ, Christ the Cornerstone Lutheran Church, and First Baptist Church of Mira Mesa. This photograph from the November 12, 1975, Mira Mesa *Sentinel* shows Dean Shipley (left) and Gary Reed of Christ the Cornerstone Lutheran Church accepting the trees from Charlene Ellsworth. (CE.)

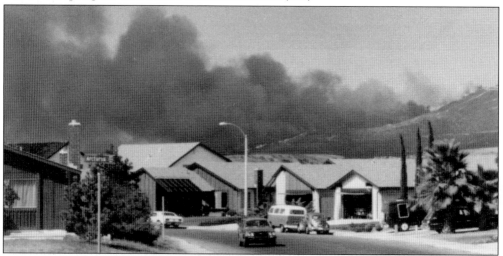

1979 BRUSH FIRE IN MIRA MESA. Brush fires are a common hazard in San Diego County, particularly in the canyons that run through the communities. Mira Mesa High School served as an evacuation for neighboring communities during both the 2003 Cedar Fire and 2007 firestorm. This 1979 brush fire in northeast Mira Mesa, seen from the corner of Bootes Street and Arcturus Way, turned out not to be serious but brought the neighbors together. (SMM.)

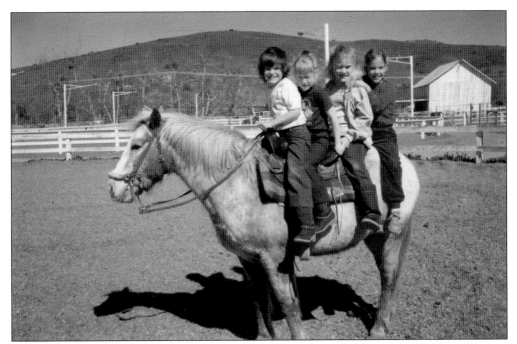

HORSEMAN'S PARK 1984. Horseman's Park, at the east end of Los Peñasquitos Canyon Preserve on Black Mountain Road, provided pony rides for kids, as shown in this picture. They also rented horses for people to ride into the 6-mile-long preserve. Presently Canyonside Stables is located at the site, providing horse boarding and riding lessons via its sub-lessee, Horsebound. Shown in the 1984 picture above are, from left to right, Heide Culea and Sarah, Nikole, and Shannon McCollum. (SMM.)

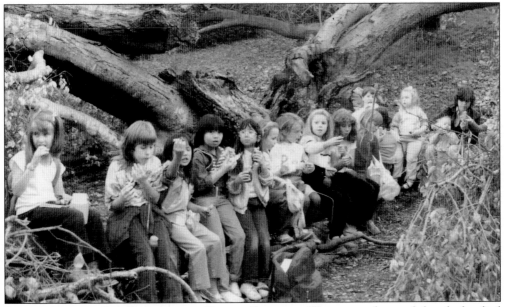

EICHAR GRAVE IN LOS PEÑASQUITOS CANYON PRESERVE. The grave of a ranch hand who died in the 1800s is a popular short hike for scout troops and other hikers. Shown in this picture is a Brownie Girl Scout troop at the Eichar grave in 1986. (PJS.)

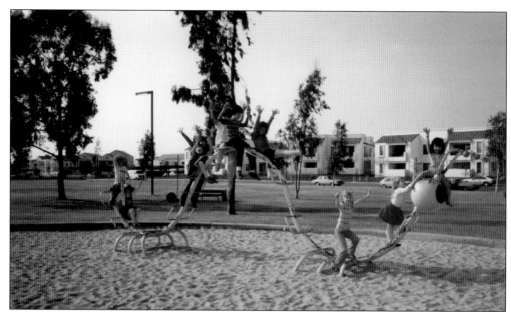

MIRA MESA COMMUNITY PARK. Mira Mesa Community Park opened in 1977 and quickly became a recreational focal point for the community. These two pictures from 1985 show the children's play area and a pile of children enjoying the park. The photograph above is of the children on the "caterpillar" climbing structure that was in the playground during the 1980s. Below, the same group of children arranged themselves in a pyramid, with a sign visible above their heads that reads "City of San Diego Mira Mesa Community Park and Gil Johnson Recreation Center." The recreation center was named after Gil Johnson in recognition of his help as Mira Mesa's representative on the San Diego City Council during the 1970s when local residents were fighting for community facilities. Pictured below are, from left to right, (first row) Jeff Bennett, Lisa Nissen, Nikole McCollum, and David Cummins; (second row) Shannon McCollum, Alison Cummins, and Sarah McCollum; (third row) Kristy Nissen, Katie Cummins, and Jennie Bennett. (Both SMM.)

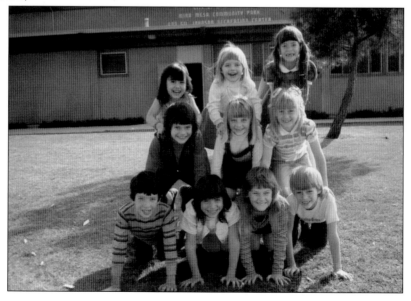

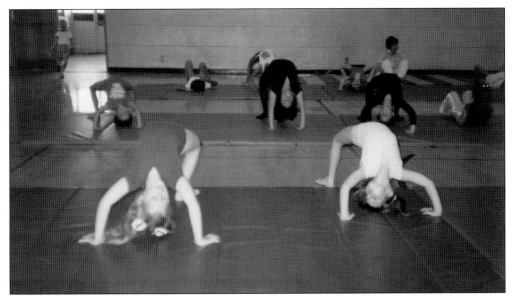

MIRA MESA RECREATION CENTER. Located in Mira Mesa Community Park, the Gil Johnson Mira Mesa Recreation Center is used for a wide variety of recreational programs. Shown above is a gymnastics program in one of the interior rooms in 1983 and below is a swimming program in a portable pool set up on the patio outside the recreation center during the summer of 1988. For many Mira Mesa families in the 1980s, the portable pool program was the way their children learned to swim. Larwin homes in northeast Mira Mesa had homeowners' association pools, and the Mesa Racquet Club was a private gym with a pool in Mira Mesa at the time, but there was no public swimming pool. Mira Mesa's first community pool did not come until 1999, when the $4 million, three-pool Ned Baumer Aquatic Center opened as a joint-use facility for Miramar College students and the community at Hourglass Field Park on the southwest corner of the Miramar College campus. (Above, SMM; below, PJS).

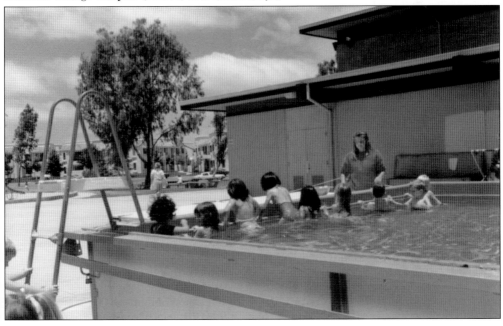

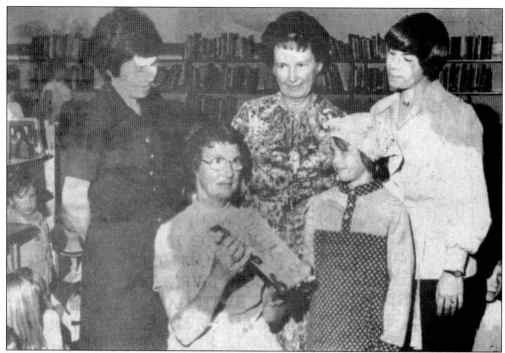

VI SCHNEIDER. Vi Schneider was a very active Mira Mesa volunteer in the late 1970s. Schneider was not only a helper at Walker Elementary School, where she is shown being honored for her involvement with the school library, but was also active in the early days of the Mira Mesa Golden Friends as a strong proponent of building a senior center in Mira Mesa. This news photograph was published in a Mira Mesa community newspaper that is no longer in publication. (W.)

VERNE GOODWIN, VOLUNTEER OF THE YEAR. In 1984, the Mira Mesa Town Council began an annual tradition of selecting a Mira Mesa Volunteer of the Year based on a long history of community service. The first volunteer of the year, Verne Goodwin, was an active member of the Golden Friends, chair of the Mira Mesa Community Planning Group, chair of the Los Peñasquitos Canyon Preserve Citizen's Advisory Committee, and was almost single-handedly responsible for getting the Mira Mesa Senior Center built. The senior center was named in Verne Goodwin's honor at the time of its 20th anniversary in November 2006, and new metal letters adding his name to the outside of the building went up not long before his passing at the age of 90 in March 2008. (TB.)

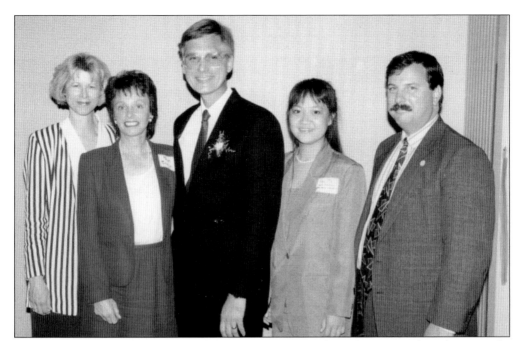

BRUCE BROWN, COMMUNITY VOLUNTEER. Bruce Brown is the only person selected twice to be Volunteer of the Year, in 1986 and 1994. Active in the community since the early 1980s, Bruce Brown has been Mira Mesa Town Council president, Mira Mesa Community Planning Group chair, and Mira Mesa Recreation Council chair, as well as a member of the city's planning commission and the city's park and recreation board. Above, local political representatives honor Bruce Brown at his 1994 award dinner. Shown are, from left to right, Annette Hubbell, aide to state senator Dave Kelley; San Diego School Board member Sue Braun; Bruce Brown; Yen Tu, aide to council member Barbara Warden; and Tom Cleary, aide to Congressman Randy "Duke" Cunningham. (PJS.)

DUAL VOLUNTEERS. In 1992, the Mira Mesa Town Council selected two volunteers of the year, Jeff Stevens and Sharon McCollum. McCollum was an active volunteer with the Girl Scouts and Mira Mesa schools. Stevens was president of the Mira Mesa Town Council and chair of the Mira Mesa Community Planning Group. The volunteer of the year dinner is also a fund-raiser for the Mira Mesa Town Council/Verne Goodwin college scholarship for graduating high school seniors from Mira Mesa based on their community service, not grade point average, encouraging local youth to get involved as volunteers. (PJS.)

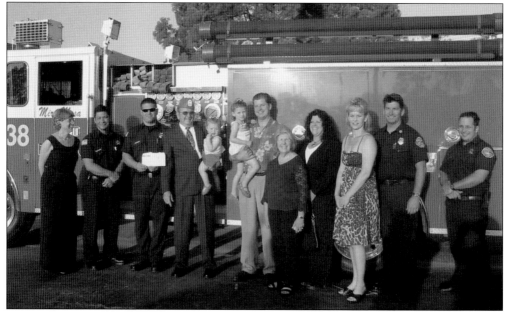

CHUCK SWEET WITH FIRE ENGINE. Longtime Mira Mesa volunteer Chuck Sweet (center, wearing fire helmet) retired as a firefighter in the Boston area before moving to Mira Mesa in 1986 and becoming active with the Golden Friends, the senior center, and the Mira Mesa Town Council. He was selected as volunteer of the year for 2006. The local fire department brought a fire engine to his honorary dinner that took place at the Mira Mesa Senior Center on April 28, 2007. (PJS.)

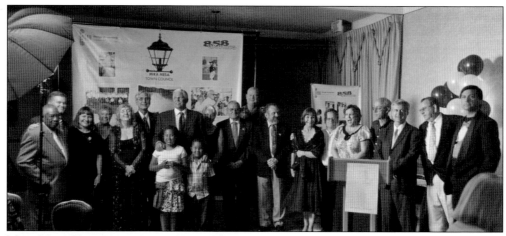

MIRA MESA VOLUNTEERS OF THE YEAR. This picture taken at Ted Brengel's Volunteer of the Year Dinner in 2009 shows past Volunteers of the Year who came to celebrate the event. From left to right are (first row) Ted Brengel's grandchildren Natasha and Eric; (second row) Larry Brady, Keith Flitner, Pam Stevens, Sandra Archer (formerly Sparks), Robin Stutsman, Bruce Brown, Ted Brengel, Brenda Bowman, Bob O'Hara, Marv Miles, John Malo, Debbie Vincent, Steve Stutsman, Karen Burger, Joe Frichtel, Chuck Sweet, Jeff Stevens, and Mike Davis. Volunteers of the Year not pictured here are Verne Goodwin, John Worthington, Dawn Gutierrez, Sharon McCollum, Eldon Jacobs, Tim Allen, Orlando Vernacchia, and Sandy Smith. (TB.)

ORLANDO VERNACCHIA AND MAYOR JERRY SANDERS. Orlando Vernacchia was a longtime, dedicated Mira Mesa volunteer well known for speaking his mind, as he is doing here with San Diego mayor Jerry Sanders in April 2007. Vernacchia and his wife, Roberta ("Bobbie"), moved to Mira Mesa in 1978. He was active with the Mira Mesa Fourth of July Committee, town council, the Halloween carnival, and other committees. When he died at the age of 92 on January 4, 2010, the community of Mira Mesa lost a friend, as well as one of its most active voices. (PJS.)

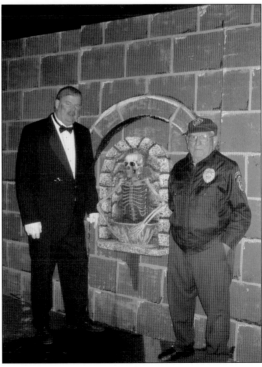

MARV MILES AND ORLANDO VERNACCHIA. Shown here are 1997 Volunteer of the Year Marvin "Marv" Miles (left), 1989 Volunteer of the Year Orlando Vernacchia, and an unnamed skeleton welcoming visitors to the Mira Mesa Monster Manor, a haunted attraction run by volunteers each October since 2001. In 2010, Marvin Miles, a Mira Mesa realtor, became president of the recently reincarnated Mira Mesa Chamber of Commerce. (PJS.)

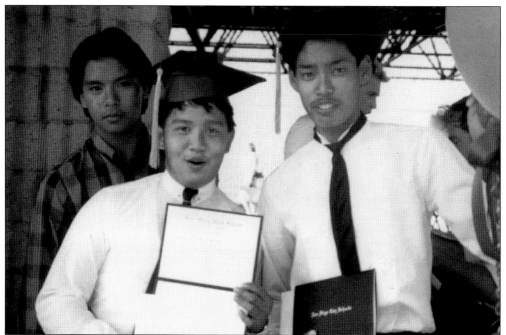

MIRA MESA HIGH SCHOOL GRADUATION. Mira Mesa High School, a Blue Ribbon Schools Program school and California Distinguished School, has graduated at least 500 students per year for more than 30 years. Shown in this picture from 1985 are Willie Norris (left) and Marlon Austria with their diplomas, and Reggie Norris in the background. The Mira Mesa High School Foundation, created in 2004, began a popular farmers market in 2009 on the northeast corner of campus. (MA.)

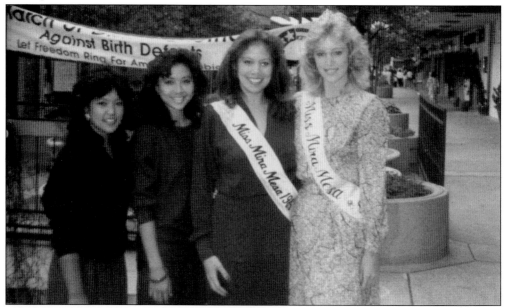

MISS MIRA MESA. Miss Mira Mesa was associated with the Fairest of the Fair pageant of the Del Mar Fair during the 1980s. Shown here, from left to right, are four Miss Mira Mesas: Olivia Austria, 1983; Cindy Vales, 1984; Lani Ardelle, 1985; and Sharon Cole, 1986.

LUAU AT ERICSON ELEMENTARY SCHOOL. For many in Mira Mesa, life revolves around events at their local school. Shown here is a spring luau at Ericson Elementary School on May 28, 1986. (SMM.)

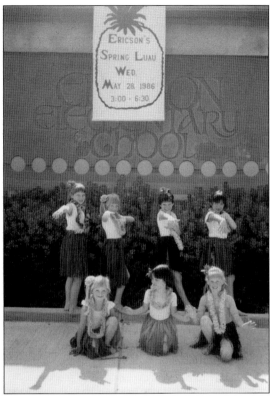

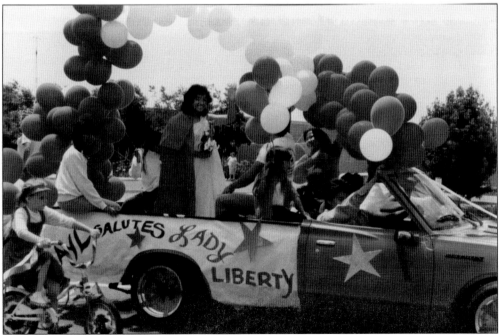

AYL SALUTES LADY LIBERTY. The Association of Youth Leaders (AYL) was a Filipino youth group for those aged 12 to 21 years old that participated in many community events. Shown above is the AYL entry in the 1986 Mira Mesa Fourth of July parade. (MA.)

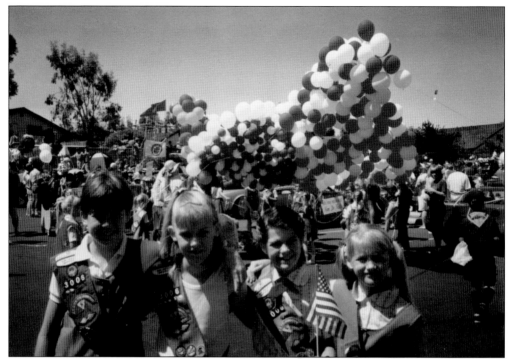

GIRL SCOUTS WITH BALLOONS. Girl Scouts participated in the 1987 Fourth of July parade with many, many balloons. (SMM.)

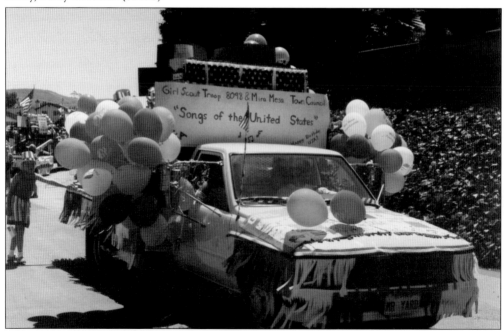

GIRL SCOUTS/MMTC FOURTH OF JULY PARADE. Girl Scout Troop No. 8098 joined with the Mira Mesa Town Council (MMTC) for this entry in the 1989 Fourth of July parade. The float created was a singing hayride with a decorated truck piled with bales of hay and Girl Scouts in back, all singing, "The United States." (PJS.)

BOY SCOUTS CARRY THE PARADE BANNER. Mira Mesa Boy Scouts carry the parade banner in the 1994 Mira Mesa Fourth of July parade. (PJS.)

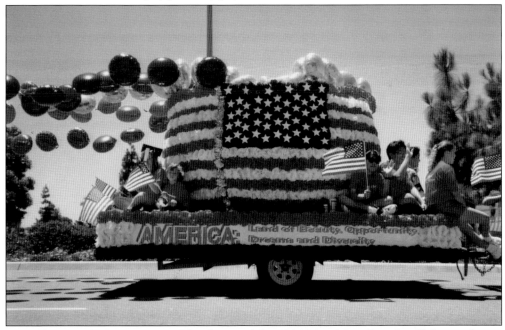

1994 FOURTH OF JULY PARADE. The theme of the 1994 Mira Mesa Fourth of July parade was America: Land of Beauty, Opportunity, Dreams and Diversity. The Best Display of Theme award went to the entry shown above by Collins Family Jewelers, a decorated float with children riding and people holding balloons walking alongside. What at first appeared to be a curving U.S. flag, surrounded by children and marchers of many ethnic backgrounds, turned out to be a giant "melting pot" with gold balloons bubbling out of the melting pot. Creating the float was an effort of many people, with the key partnership a group of several families who enjoy doing things together. Collins Family Jewelers is located at the Mira Mesa Mall. (PJS.)

LUMPIA AT THE FOURTH OF JULY CELEBRATION. The Fil-Am Association served lumpia at the 1994 Fourth of July Family Fun Day in Mira Mesa Community Park. In charge of the booth were Aida Agbayani, Belen Cadelina, and Ed Cadelina, assisted by other members of the Fil-Am Association of San Diego North County. (PJS.)

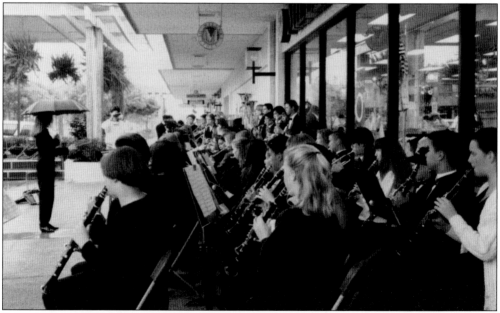

RAINY I LOVE MIRA MESA DAY. Rain did not stop the Mira Mesa High School Sapphire Sound Band from performing at the 1995 I Love Mira Mesa Day. Band director Jeanne Merrill made sure her students set up for their performance so they were protected as much as possible by the overhang of nearby shops, then conducted the band from under an umbrella. (PJS.)

Five

GROWING PAINS

As Mira Mesa grew, the community acquired more services and became less isolated. During the 1980s and into the 1990s, the community grew at a rate many residents found too rapid, and growth started to impact sensitive areas such as Los Peñasquitos Canyon Preserve, causing additional controversy. Mira Mesa Boulevard was completed west to Interstate 805 in 1983, improving access but also causing a big increase in traffic passing through the community.

Although by this time Mira Mesa had good schools and enough parks for the 1980 population, additional growth caused the community to fall behind population-based park standards. As a result, in the late 1980s city councilman Ed Struiksma worked with the Mira Mesa Community Planning Group to identify additional park sites and update the Mira Mesa Community Plan. Also during the 1980s, the Facilities Benefit Assessment (FBA) was established. As a condition of their building permits, developers pay into this fund, which then pays for parks, roads, fire stations, and libraries.

The growth concern came to a head in 1989 when a very controversial project, Miramar Ranch North, was proposed for the north side of Miramar Lake, just east of Mira Mesa. This caused a period of rapid change in city council representatives. Ed Struiksma, who was regarded as pro-growth and took most of the blame for Miramar Ranch North, lost the 1989 election to Linda Bernhardt, a former staff member for city council member Abbe Wolfsheimer. Bernhardt then made a political mistake by supporting a redistricting map that removed Miramar Ranch North from her council district. A recall campaign removed Bernhardt from office and she was replaced by Scripps Ranch resident Tom Behr.

By the end of the 1990s, growth was still rapid but the layout of the community was established and followed the community plan developed a decade earlier quite closely. Western Mira Mesa was developing into a vibrant, high-tech business area. A new, larger library was built and Hourglass Park was built at Miramar College on the site of the old Hourglass Field.

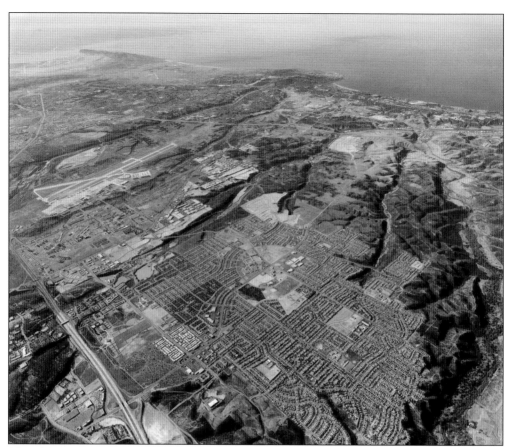

MIRA MESA C. 1980, LOOKING SOUTHWEST. The Mira Mesa Mall and Mira Mesa High School can be seen in the center of the community, to the northwest and southeast, respectively, but there is bare dirt at the site of the future Target (initially Gemco) shopping center. Mira Mesa Boulevard ends at Parkdale and none of the industrial development in western Mira Mesa has started. There is a dirt road leading west from the end of Mira Mesa Boulevard. Black Mountain Road north of Mira Mesa Boulevard on the east side of the community is a narrow, winding road. There are a few buildings at Miramar College, which was then primarily a training facility for San Diego's law enforcement personnel and firefighters, but the hourglass of the old Hourglass Field is still clearly visible. (MM.)

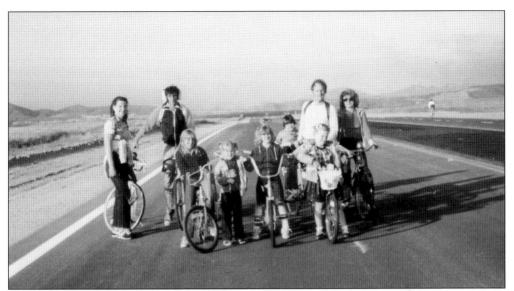

MIRA MESA BOULEVARD OPENS WESTWARD. Bicyclists enjoy a ride on the new Mira Mesa Boulevard just before it opened to automobile traffic. The long-awaited opening of Mira Mesa Boulevard took place in 1983, and traffic rapidly increased to make it one of the most heavily traveled streets in San Diego. Originally four lanes, the road has since been widened to six and eight lanes. (SMM.)

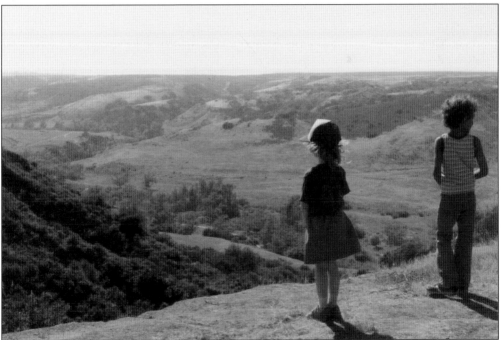

OVERLOOKING LOS PEÑASQUITOS CANYON PRESERVE. Development started to occur around the edges of Los Peñasquitos Canyon Preserve and on Lopez Ridge, causing controversy and opposition. In this picture, two young Mira Mesa residents look out over the undeveloped preserve. Although some of the northern slopes and Lopez Ridge were developed for housing, 4,000 acres, including the entire canyon bottom, have been preserved. (PJS.)

ON THE EDGE OF LOS PEÑASQUITOS CANYON PRESERVE. These ridge tops on the edge of Los Peñasquitos Canyon Preserve became housing developments in the 1990s. Although not as controversial as the Peñasquitos and Lopez Ridge developments, the mesa top houses are quite visible from the canyon bottom. (Both PJS.)

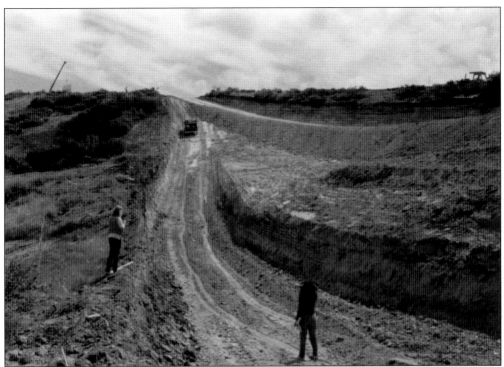

LOPEZ RIDGE ROAD DEVELOPMENT. A major road, Calle Cristobal/Sorrento Valley Boulevard, was built down the center of Lopez Ridge and through the west end of Los Peñasquitos Canyon. About 2,000 houses were built on Lopez Ridge. To allow deer to move safely from Lopez Canyon to Los Peñasquitos Canyon, a large tunnel was built beneath the road at the end of a finger canyon just west of Shaw Lopez Road. (Both PJS.)

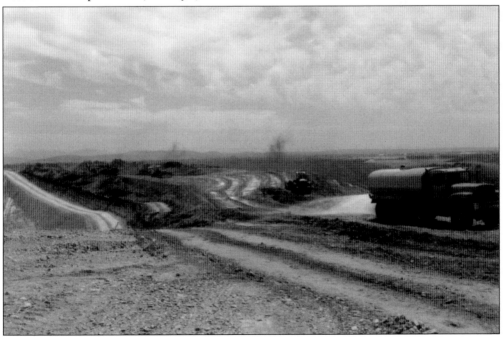

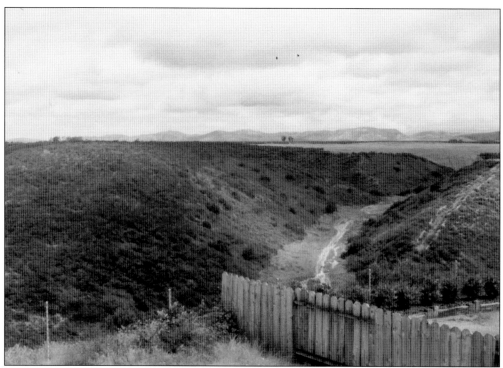

LOPEZ RIDGE HOUSING DEVELOPMENT. The picture above, taken from a house on the south side of Lopez Canyon, shows a finger canyon extending to Lopez Ridge after the initial grading for the road was completed but before grading for housing started. The picture below shows the canyon from the same viewpoint after grading for houses was completed and some of the houses were built. (Both BC.)

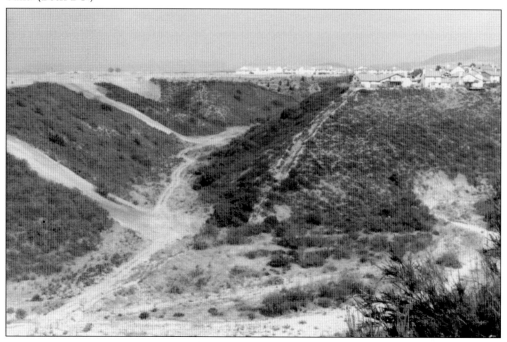

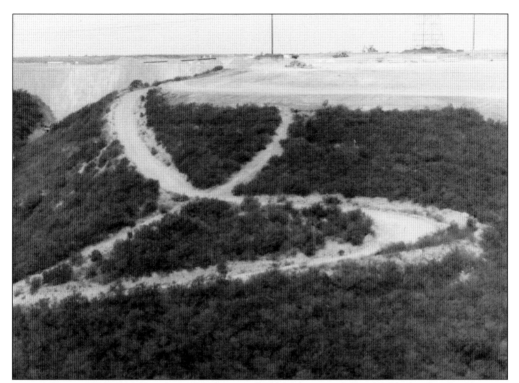

LOPEZ RIDGE GRADING. Extensive grading and fill were required to build the development on Lopez Ridge. The grading pads shown in these two pictures became Lopez Ridge Park. The stark graded and filled areas have since been revegetated to the extent that they are difficult to distinguish from the surrounding canyon today. (Both BC.)

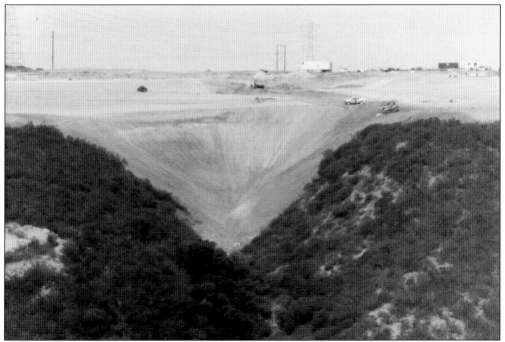

Canyon Hills Resource Park with Bulldozers in Foreground. In the distance is the northeast Mira Mesa hill that is the future Canyon Hills Resource Park. In the foreground, bulldozers start development of the Casa Mira View project in October 2010. The photograph was taken from Mira Mesa's Park-N-Ride near Mira Mesa Boulevard and Westview Parkway. In the 1980s, city councilman Ed Struiksma worked with community groups to identify park sites to make up for a deficiency in park acreage, which led to adding several parks to the Mira Mesa Community Plan, including the now developed Camino Ruiz Park at the north end of Camino Ruiz, and Breen Park at the site of the former Breen Elementary School. In addition, Struiksma negotiated a controversial purchase of this hilltop for a future scenic resource park. (PJS.)

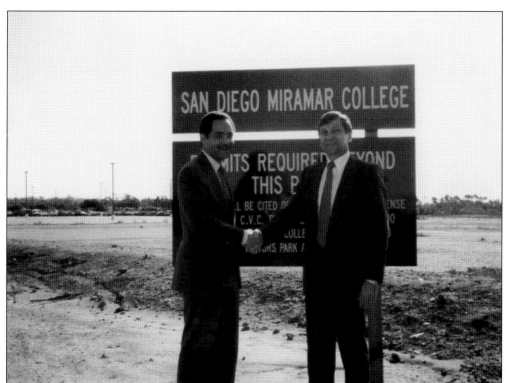

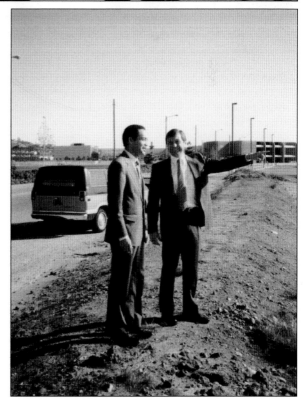

HOURGLASS PARK AT MIRAMAR COLLEGE. City councilman Tom Behr, right, and Miramar College president Dr. Jerome Hunter, left, survey the future site of Mira Mesa's third community park, later formally named Hourglass Field Community Park for the former hourglass-shaped airfield that was previously located on the site (see earlier aerial photographs). The City of San Diego and Miramar College entered into a joint use agreement for 30 acres on the south side of Miramar College to build about 25 acres of ballfields, an aquatic center with three pools, and a recreation center. These pictures were taken in 1992 at the start of Hourglass Park construction. (Both PJS.)

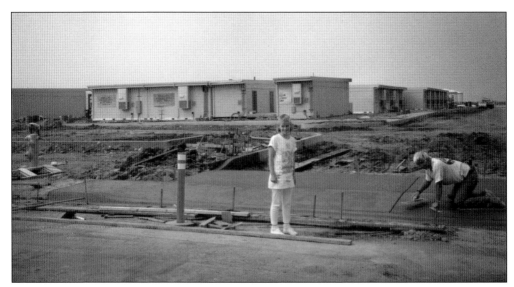

CHALLENGER MIDDLE SCHOOL UNDER CONSTRUCTION. During the early 1990s, all of the students from both Mira Mesa and Scripps Ranch attended Wangenheim Junior High School, so a high priority project was construction of a new middle school on Parkdale Avenue north of Mira Mesa Boulevard. The school opened for seventh grade only in portable buildings in 1988 while the school was being constructed on the adjacent site just to the north of the portables. It was completed in 1990 and named Challenger Junior High School in honor of the space shuttle *Challenger* and its crew. Challenger became a middle school with sixth-, seventh-, and eighth-graders in 1996. (SMM.)

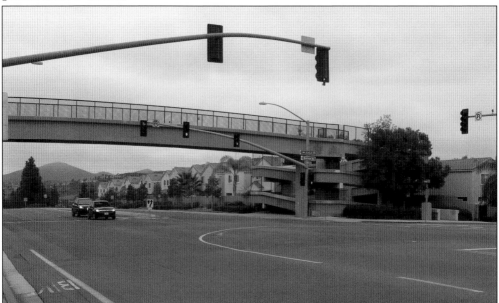

PEDESTRIAN BRIDGE OVER BLACK MOUNTAIN ROAD. When Hage Elementary School opened in 1990 east of Black Mountain Road, the all-portable, kindergarten through third grade Breen Elementary School on Polaris Drive closed and students living in that area were moved to Hage Elementary School. Because parents were concerned about their schoolchildren crossing Black Mountain Road, this pedestrian bridge was built over Black Mountain Road. (PJS.)

SCHOOL MAINTENANCE NEEDED. During the 1990s, many school facilities throughout San Diego started to deteriorate from lack of maintenance. In this picture, school board member Sue Braun, left, and state assembly member Dede Alpert examine leaks in the roof of the computer lab at Wangenheim Middle School. Such problems were one reason for School Bond Proposition MM, which was approved by voters in 1998. (PJS.)

TEEN CENTER PLANNING WORKSHOP. In the late 1980s, before the new library opened in 1994, planning started for redevelopment of the old library and surrounding area. This picture shows a design workshop with several proposed designs, including a scale model. Ultimately the former library was turned into a teen center known as the Epicentre that is operated by Harmonium, Inc., and a police storefront operated by the San Diego Police Department. The senior center is across the parking lot. (PJS.)

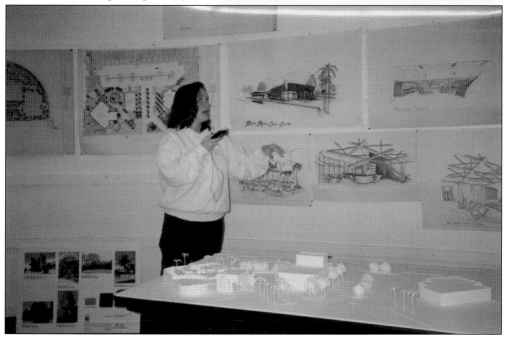

Los Peñasquitos Canyon Preserve Master Plan is Completed. The master plan for Los Peñasquitos Canyon Preserve was adopted by the San Diego City Council in November 1998. Although the preserve had been in existence since 1980 operating under an interim management and development plan, the master plan could not be adopted until much later because of an inconsistency with the Mira Mesa Community Plan, which showed Camino Ruiz extending through Peñasquitos Canyon. When the extension of Camino Ruiz was removed with the update of the Mira Mesa Community Plan in 1992, it cleared the way for adoption of the Preserve Master Plan. The pictures here and on the following page are from the mesa top that later became Camino Ruiz Park (see the next chapter). Pictured above is the mesa top with a trail leading into the canyon. Below is a look down into the canyon. Later a neighborhood park, elementary school, and residential development were built across the canyon at this point. (Both PJS.)

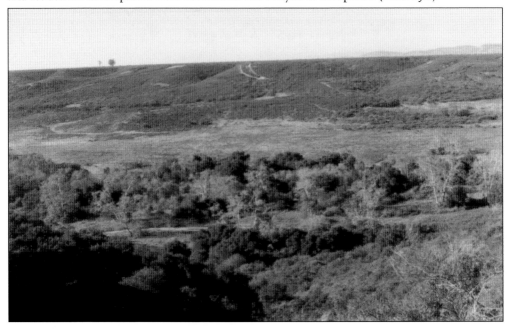

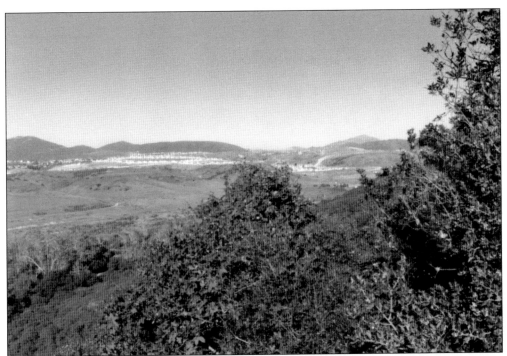

LOOKING ACROSS PEÑASQUITOS CANYON TO RANCHO PEÑASQUITOS. This picture looks across Los Peñasquitos Canyon toward Rancho Peñasquitos, which at that time was far in the distance. The hillsides on the north side of the canyon were developed under an agreement with the developer at the time the city acquired the canyon bottom. (PJS.)

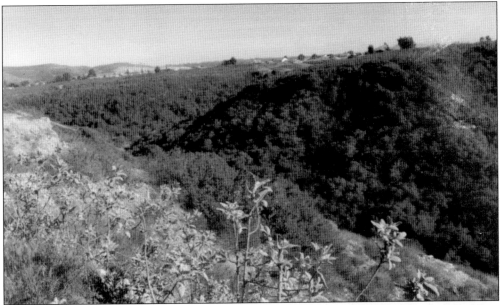

LOOKING BACK AT MIRA MESA FROM THE EDGE OF LOS PEÑASQUITOS CANYON. On the Mira Mesa side of the canyon, only the mesa tops were developed, while the slopes (which are much steeper on the south side) were all preserved. Near the spot where this picture was taken there is now a trail around the edge of Camino Ruiz Park overlooking the canyon. (PJS.)

CLEAN AND GREEN DAY. Clean and Green Day is an annual event to get rid of trash and clean up the community. In the 1980s and 1990s, it was a large event with many participants, including scout troops and school groups that were assigned to police different parts of the community. The picture shows Mira Mesa volunteers working with dumpsters provided by the city for community trash collection. Pictured on top of the dumpster is John Malo and below him is an unknown volunteer. (PJS.)

ABANDONED SHOPPING CARTS. To make a point about a persistent problem with abandoned shopping carts, on February 20, 2010, volunteers collected approximately 100 shopping carts left on Mira Mesa streets and stacked them at the Mira Mesa Mall where this picture was taken. (PJS.)

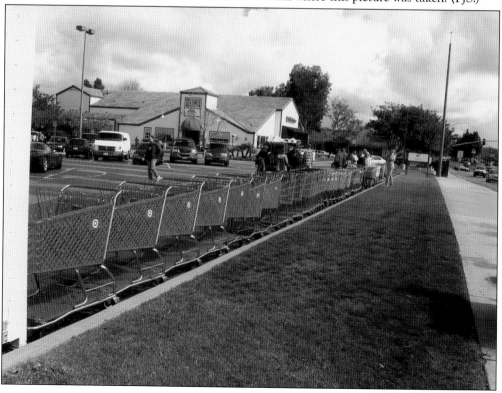

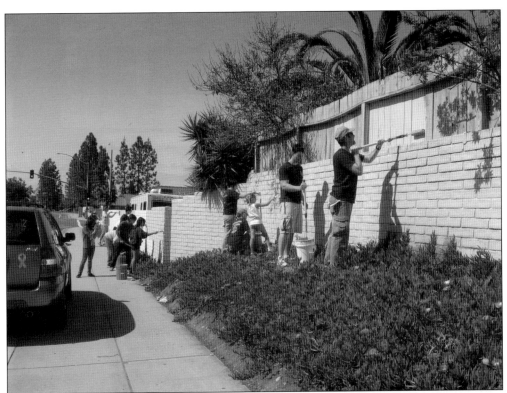

PAINTING THE COMMUNITY. Above, Mira Mesa volunteers paint fences along major streets. The fences were covered with many years of dirt and graffiti, so the repainting made a vast improvement. In the photograph below, volunteers receive an award from the police department for their graffiti paint-out work. Pictured below, from left to right, are Steve Higuera, Bruce Brown, Marv Miles, Orlando Vernacchia, Ted Brengel, and Jim Brown. (Both PJS.)

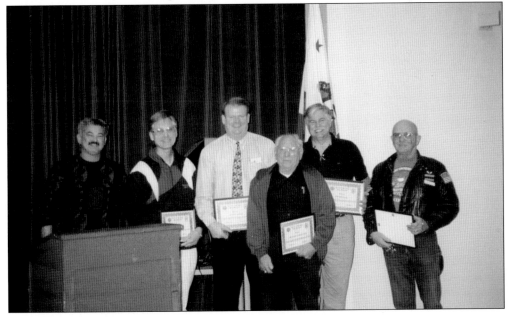

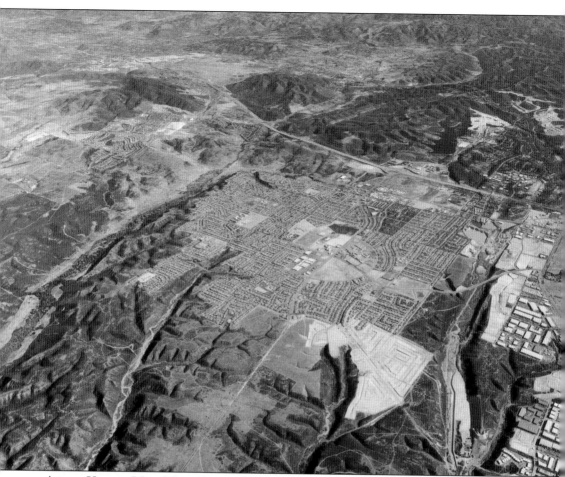

AERIAL VIEW OF MIRA MESA, LOOKING EAST. This picture of Mira Mesa was taken in 1980, just after the southwestern part of the community had been graded for development. On the southwest corner of Parkdale Avenue and Flanders Drive a large lot was created for a school and park by grading off the top of a ridge and filling the end of the two adjacent finger canyons. Maddox Park, on Flanders Drive just west of Parkdale, was completed in 1989. Several years later, a fenced area for an off-leash dog park was added at Maddox Park. The school, then known as Maddox Elementary School, was described in the 1981 Mira Mesa Community Plan as "under construction," but construction was delayed first for financial reasons and then later for environmental concerns (see next page). (MM.)

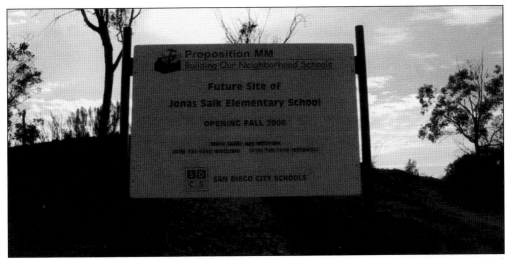

VERNAL POOLS DELAY JONAS SALK ELEMENTARY SCHOOL. The school at Parkdale Avenue and Flanders Drive was finally funded for construction by Proposition MM in 1998, was renamed after Jonas Salk, and was scheduled for completion in 2007, as pictured above. Unfortunately by this time vernal pools had formed in shallow depressions on the site, seen below, and endangered species like the San Diego fairy shrimp had taken up residence there, which delayed the school again and also made it necessary for the school district to perform mitigation for destruction of the vernal pools before building the school. As of 2010, the school district, City of San Diego, and U.S. Fish and Wildlife Service have a tentative agreement to preserve vernal pools next to Challenger Middle School so Salk Elementary School can be built. (Both PJS.)

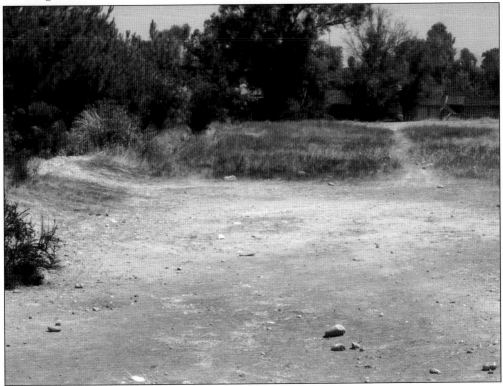

VERNAL POOLS BY CHALLENGER MIDDLE SCHOOL. Kathryn Wild, creator of the environmental group Wild by Nature, shows a group of schoolchildren in the Hickman Children's Ecology Club the vernal pools next to the Challenger Middle School. Much of Mira Mesa soil is a nearly impermeable clay and rock mix that allows rainwater to collect in shallow pools without draining for weeks or months. These vernal pools dry up in the summer months, but the fairy shrimp and other species that inhabit them appear in the winter. Many of the vernal pools in Mira Mesa were destroyed by development prior to the species becoming listed as endangered. (PJS.)

Six

MIRA MESA MATURES

In the 1990s, facilities and programs developed to solve some of the problems discussed in chapter eight. Once the permanent Challenger Junior High School buildings opened in September 1990, the new school quickly became a hub of the community. The Mira Mesa Town Council, which had been meeting at Mira Mesa Presbyterian Church during the 1980s, began holding its monthly "town hall" meetings in the Challenger auditorium.

When the new Mira Mesa Branch Library opened on the corner of Camino Ruiz and New Salem Street in July 1994, it not only provided an expanded library but also a community meeting room that offered another venue for local events. The Mira Mesa Town Council and Mira Mesa Community Planning Group both started meeting regularly at the library, although they occasionally scheduled programs in the Challenger auditorium if a larger-than-normal turnout was anticipated.

The Mira Mesa Theatre Guild was founded in 1990 as Mira Mesa's own nonprofit community theater group and performed in a variety of venues during the 1990s, including the Gil Johnson Mira Mesa Recreation Center, Challenger Junior High School, and several storefront locations. Mira Mesa High School continued to have a strong performing arts program in band, drama, and choir.

The first class of Retired Senior Volunteer Patrol (RSVP) officers graduated in September 1994. RSVP members patrol as extra eyes and ears for the police, do vacation home checks, make You Are Not Alone visits to homebound seniors, and assist with parking control and traffic control at special events. The Mira Mesa Town Council, Scripps Ranch Civic Association, and Elliot Feuerstein of the Mira Mesa Shopping Center donated funds to buy the first two patrol cars.

At the close of the 1990s, Mira Mesa had outgrown the I Love Mira Mesa Day celebration in the middle of the Mira Mesa Mall. People still enjoyed the event, but attendance dwindled as the options of what to do on Saturdays in Mira Mesa increased and the mall became no longer the obvious main gathering place. The Mira Mesa Town Council launched the beginning of a new tradition, resulting in the first Mira Mesa Street Fair taking place in October 1999.

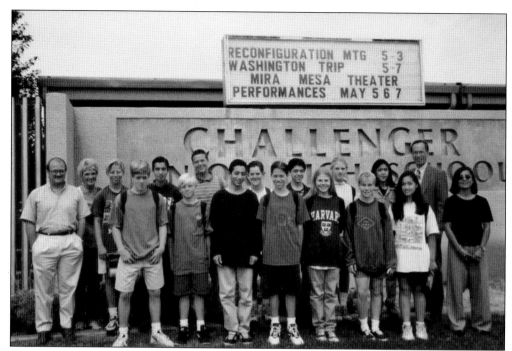

CHALLENGER JUNIOR HIGH BECOMES HUB OF COMMUNITY. Visible over the tops of the Challenger Junior High School eighth grade students and chaperones heading on their educational/cultural East Coast trip to Washington, D.C., and New York City, the school marquee in this 1995 photograph includes announcements about an upcoming Mira Mesa Theatre Guild performance in the school's auditorium, as well as a "reconfiguration meeting" to discuss the coming shift to kindergarten through fifth grades in elementary schools and sixth through eighth grades in middle schools. (PJS.)

HOURGLASS PARK RIBBON CUTTING. On December 4, 1993, a ribbon cutting ceremony took place to open Hourglass Field Community Park on the southwest corner of the Miramar College campus at Black Mountain Road and Gold Coast Drive. Community leaders and dignitaries joined in celebrating the joint-use park, which provided ballfields for the community. Pictured, from left to right, are Cynthia Meinhardt, Damon Schamu, Jeff Stevens, Maria Nieto Senour, Dr. Lous Murillo, Ed Struiksma, Mike Madigan, Barbara Warden, David Poole, Tom Behr, Augustine Gallego, Bruce Brown, Mary Ann Oberle, Fred Colby, Robin Terrell, and Nancy Acevedo. (PJS.)

MIRA MESA LIBRARY CONSTRUCTION. A ground-breaking ceremony for the new Mira Mesa Branch Library took place on January 24, 1993. Library construction followed many presentations by the architects, BSHA Design Group, and much discussion at Mira Mesa Community Planning Group meetings. Pardee, Inc., provided the $3 million funding necessary for construction of the library as part of its Westview development agreement, and the ground-breaking ceremony took place on the first sunny Sunday of the New Year. Bagpipes played and the community celebrated. In the photograph above, David Poole of Pardee, Inc., presented a symbolic giant check to city council member Tom Behr, accompanied by young fans of the library. In the photograph below, the beams of the library under construction show it starting to take shape at the corner of Camino Ruiz and New Salem. (Above, PJS; below, MMBL.)

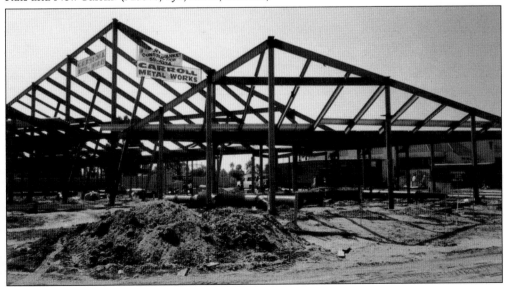

MIRA MESA LIBRARY BOOK PASSING. Prior to the new Mira Mesa Branch Library opening in July 1994, the call went out to Mira Mesa residents to join in a "book passing" to help move the last volumes from the old branch at 8450 Mira Mesa Boulevard to the new branch at 8405 New Salem Street. Looking like a scene from a Dr. Seuss book, the human chain stretched from the back of the old library building along the side of the parking lot for the Mira Mesa Office Mall and Medical Mall, to the rear doors of the new, expanded library. The distance was about the length of a long city block. Friends of the Library, Scout troops and other youth groups, families, and Mira Mesans of all ages joined in the effort, shown above in a close-up photograph of part of the line and below in a wider view. (Above, PJS; below, JP.)

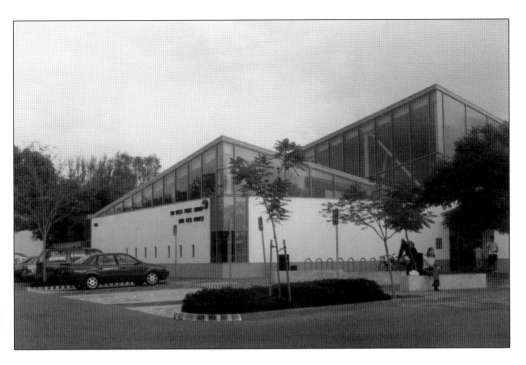

MIRA MESA LIBRARY OPENS. The grand opening of the expanded, 20,000-square-foot Mira Mesa Branch Library took place on Sunday, July 10, 1994. The photograph above shows the library exterior approached from the parking lot at the corner of New Salem and Camino Ruiz. The photograph below offers a glimpse at the interior of the new library. The community meeting room was designed to seat 100 people, a great improvement over the former 8,000-square-foot branch library's alcove area for group meetings. The Mira Mesa Library Branch manager at the time the new branch opened was Deborah Graf and the youth services librarian was John Bishop. In 2010, the Mira Mesa Library Branch manager was Lien Dao and the youth services librarian was Teresita Flores, both Mira Mesa residents. (Both MMBL.)

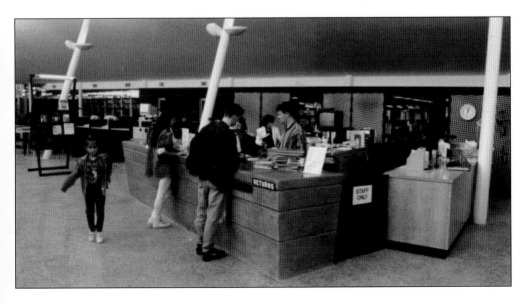

LOCAL THEATRE IN MIRA MESA. Above, the Mira Mesa Theatre Guild—Mira Mesa's first community theater group—was founded in 1990 by Carla Brandon and incorporated as a 501c(3) nonprofit group in 1991 when the group held a youth theatre workshop. In 1992, the guild debuted its first full-length play, *Good Ol' Radio Daze*, performed for two weekends at the Mira Mesa Recreation Center. Pictured, from left to right, are (first row) Christopher Whenry; (second row) Karen Ricks, Mary Ann McKay, and Kristin Prewitt; (third row) Frank Mangano, Larry Sawh, Tim Huntley, Thomas Butler, and Martin White. Mira Mesa High School Drama's powerful production of *Inherit the Wind*, seen below, took place two years later in 1994. Pictured are graduating seniors Jeff Allen, left, and Christopher Whenry, who starred in the leading roles of courtroom opponents Matthew Harrison Brady and Henry Drummond, respectively. (Above, CB/MMTG; below, PJS.)

NAS/MCAS MIRAMAR, A GOOD NEIGHBOR. Both the U.S. Marine Corps and the U.S. Navy—which was the U.S. Marine Corps' predecessor prior to the conversion from Naval Air Station (NAS) Miramar to Marine Corps Air Station (MCAS) Miramar—have been good neighbors to Mira Mesa. Base representatives attend planning group meetings. The Mira Mesa Town Council has held several of its volunteer of the year dinners on base in the officers club. At the August 1990 event, guests were invited by NAS Miramar to a cockpit tour of the hangars and planes prior to dinner. Pictured are 1990 honoree Pam Stevens along with her husband, Jeff, and daughters, Brenda and Sharon. (PJS.)

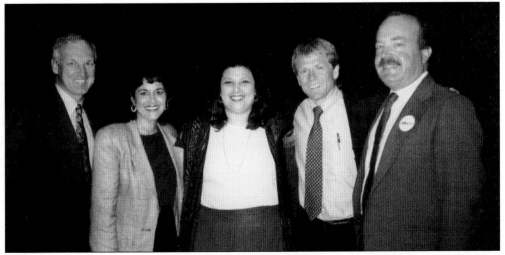

MIRA MESA TOWN COUNCIL CANDIDATES FORUM. The Mira Mesa Town Council organizes candidates' forums to inform voters prior to major elections. This photograph from May 1992 shows all four mayoral candidates in the primary election that year together with Mira Mesa Town Council president Linda Moog. Pictured, from left to right, the candidates are Ron Roberts, then a San Diego City Council member; Susan Golding, then a San Diego County Supervisor; Linda Moog; economics professor Peter Navarro; and San Diego businessman Tom Carter. (PJS.)

LOS PEÑASQUITOS CANYON PRESERVE PARK DAY 1994. In the 1980s and 1990s, an annual celebration took place in Los Peñasquitos Canyon Preserve called Park Day, with entertainment and food available at the adobe ranch house courtyard. Held sometimes in the spring, sometimes in the fall, it also included guided hikes and activities. Today the county sponsors a National Trails Day celebration the first Saturday in June, and the San Diego Archeological Society holds annual Arch in the Park celebrations with a similar atmosphere. The photographs above and below show participants enjoying Park Day 1994. Shown below are Bob and Gaye Dingeman of Scripps Ranch. Bob was one of the early members of the Los Peñasquitos Canyon Preserve Citizens Advisory Committee, and Gaye has been active with the Friends of Los Peñasquitos Canyon Preserve. (Both PJS).

WATERFALL IN LOS PEÑASQUITOS CANYON. At right and below are photographs showing hikers exploring the waterfall in the heart of Peñasquitos Canyon. Eagle Scout projects have helped provide safe access and a bench at an overlook on the north side of the falls. There are now several approach routes to the falls, from either the east or west parking lots, from Park Village neighborhood park in Rancho Peñasquitos on the north, or from the Camino Ruiz Park trail in Mira Mesa. (Both PJS.)

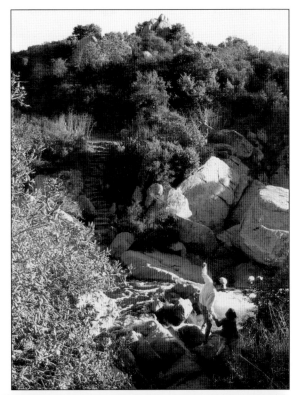

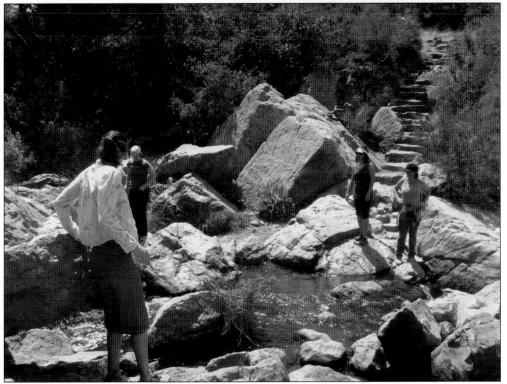

RETIRED SENIOR VOLUNTEER PATROL (RSVP). This photograph of the first graduating class of the Retired Senior Volunteer Patrol (RSVP) for Mira Mesa and Scripps Ranch was taken in September 1994 at the Scripps Ranch Library. Pictured, from left to right, are (first row) San Diego Police Department Community Service officer Paddy Keovoravongsa (now Phet Guiney), SDPD Northeast Division captain Lee Vaughan, SDPD officer Fred Wilson, SDPD Community Relations officer Steve Higuera, and SDPD lieutenant Fred Moeller; (second row) Bob Hubbard, Foud Feretti, Nanette Welch, Ginger Hines, Ruby Amon, Betty Calvert, and Letha Michel; (third row) SDPD officer Karen Daniels, three unidentified, Resty Supnet, (with Lou Andrade behind him), Al Hoy, (unidentified behind him), Norm Linsky, Carver Anderson, Dick Vanek, Dolores Moog, Kent Calvert, Julian Parish, Evan Weatherfield, two unidentified, Orlando Vernacchia, RSVP administrator Eldon Jacobs, Bob Amon, two unidentified, Tom Day, and SDPD chief of police Jerry Sanders. (LS/MM.)

EPICENTRE TEEN CENTER, POLICE STOREFRONT. In 1999, the former Mira Mesa Branch Library was remodeled and became the Epicentre teen center, managed by the nonprofit social service agency Harmonium, Inc. The Epicentre offers after school programs and a place where teens can gather, as well as evening concerts and a venue for special events. A police storefront was located next to Epicentre in another part of the building, which became the new headquarters for the Retired Senior Volunteer Patrol (RSVP). In May 2007, volunteers from HEROES, the nonprofit fix-it group led by Mike Davis, repainted the Epicentre and police storefront. Above, Mike Davis, seen at the bottom of the ladder, and a crew repaint the Epicentre. Pictured below, the police storefront is in the foreground, with a bit of Mira Mesa Community Park beyond. (Both PJS.)

VETERANS MEMORIAL FLAG. This large flag in front of the Mira Mesa Senior Center, first installed in the mid-1980s as part of a veteran's memorial, is pictured in 1994. It has also served as the location for a number of community events, including Veterans Day ceremonies and a memorial the week following September 11, 2001. (PJS.)

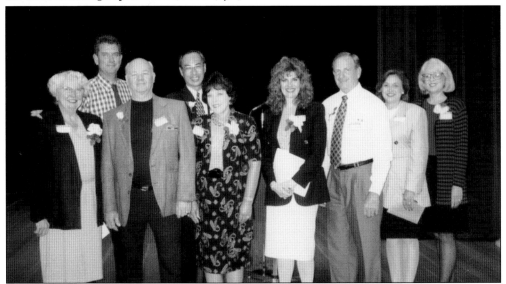

MIRA MESA SCHOOL PRINCIPALS. Most of the principals from Mira Mesa schools discussed education and their schools at this Mira Mesa Town Council meeting on October 2, 1995. This became an annual Education Night tradition at October Mira Mesa Town Council meetings. Shown are, from left to right, Dr. Gail Guth, Ericson Elementary; Frank Peterson, Hickman Elementary; Tom Crellin, Mason Elementary; Sam Wong, Challenger Junior High; Gloria Coleman, Sandburg Elementary; Dr. Elaine Arms, Walker Elementary; Del Evans, Wangenheim Middle; Rachel Flanagan, Mira Mesa High School; and Dr. Barbara Brooks, Scripps Ranch High School. (PJS.)

CHALLENGER MEMORIAL. By the late 1990s, Challenger Middle School students were too young to remember the *Challenger* explosion. However, they were well aware of the contributions and legacy of the crew of their namesake space shuttle, as are Challenger students today. In January 1997, students, faculty, and parents gathered for this commemoration of the space shuttle *Challenger* in the school's "shuttle court," a central quad with a full-size mosaic of the space shuttle. The ceremony concluded with seven Challenger Astronomy Club students each holding a candle in memory of one of the seven crew members. (PJS.)

WANGENHEIM LIGHTS DEDICATION. San Diego City Councilman Brian Maienschein and community leaders dedicated lights to allow night use of the fields at Wangenheim Middle School. This followed a controversy where lights installed at Lopez Ridge Park caused a neighborhood protest, and the lights were relocated to the Wangenheim fields. Pictured are, from left to right, Orlando Vernacchia, Chuck Sweet, Debbie Vincent, Robin Stutsman, Park and Recreation Director Ellen Oppenheim, Brian Maienschein, Joe Frichtel, Sarah Young, and Pam Stevens. (PJS.)

BREEN PARK OPENS. One of the parks initiated by Ed Struiksma in the late 1980s, Breen Park, was finally completed and opened on October 19, 2005. Active Mira Mesa volunteers and others who joined in the ribbon cutting ceremony shown above include, from left to right, Orlando Vernacchia, Janna Maienschein with Taylin Maienschein (standing) and Brenna Maienschein (being held), San Diego city councilman Brian Maienschein, Arlette Ballew, Mira Mesa Recreation Council chair Joe Frichtel, Al Radick, Chuck Sweet, Wilbur Mills, and Jeff Stevens. (PJS.)

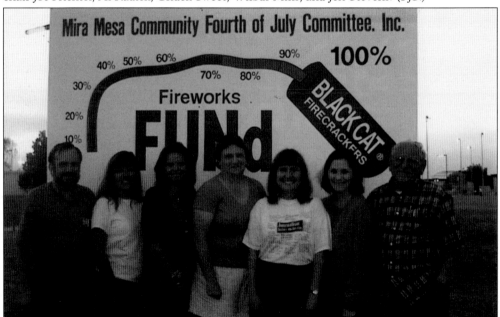

MIRA MESA FOURTH OF JULY COMMITTEE. A small group of people who put on a large event, the Mira Mesa Fourth of July Committee, is shown here in 2000. They raise the money required for fireworks and other expenses and do all of the organizing for the Fourth of July celebration. From left to right are John Malo, Rosita McLaurin, Judy Slayter, Karen Burger, Pam Stevens, Debbie Vincent, and Orlando Vernacchia. (PJS.)

MIRA MESA COLOR GUARD. The Mira Mesa High School Sapphire Sound Color Guard performed in the 2009 Mira Mesa Fourth of July parade. (PJS.)

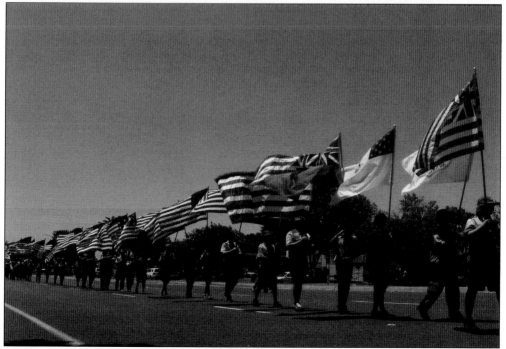

BOY SCOUT FLAG PARADE. Boy Scouts marched with historic flags in the 2009 Mira Mesa Fourth of July parade. (PJS.)

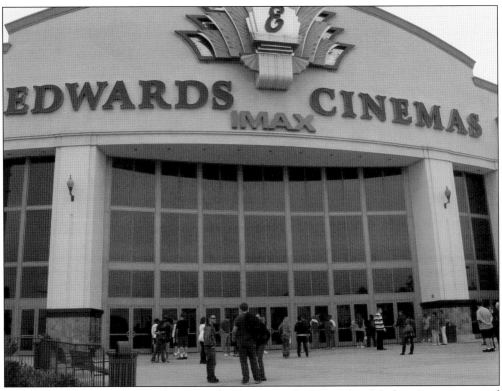

EDWARDS MOVIE THEATERS. The Edwards Cinema at the Mira Mesa Market Center, pictured above, has 18 screens. It replaced two earlier theaters, the Edwards 4 at the Mira Mesa Mall, which was demolished, and the Edwards 7 in the Target shopping center, which has been turned into the Vinh-Hung Asian Market, pictured below. (Both PJS.)

BARNES & NOBLE AT THE MIRA MESA MARKET CENTER. A welcome addition to the Mira Mesa community, this Barnes & Noble bookstore was built as part of the Mira Mesa Market Center, opening in August 2000. (PJS.)

CHINESE NEW YEAR CELEBRATION AT THE MIRA MESA LIBRARY. Due to rain, this Chinese New Year celebration took place inside the Mira Mesa Library rather than outdoors on the patio. It made the dragon dancers seem even more spectacular! Vietnamese and Chinese New Year celebrations are an annual tradition at the library. This photograph was taken in 2005. (PJS.)

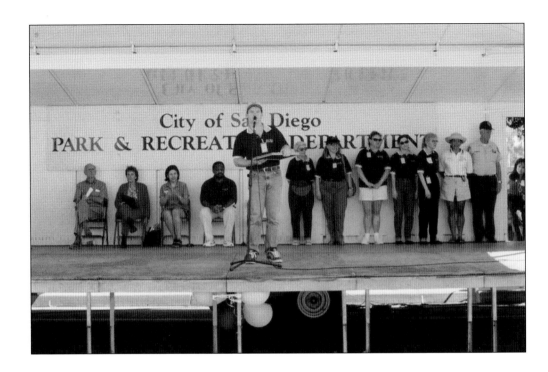

MIRA MESA STREET FAIR. Starting in October 1999, when these pictures were taken, the Mira Mesa Street Fair replaced I Love Mira Mesa Day with a much larger celebration, closing Camino Ruiz between Mira Mesa Boulevard and New Salem for a full day event. The event is sponsored by the Mira Mesa Town Council and includes most other community groups as well as local businesses, crafters, and food vendors. The picture above shows Mira Mesa Town Council president Keith Flitner at the community ceremony for this event. The picture below shows a tank arriving for the event from Marine Corps Air Station Miramar. (Both PJS.)

STREET FAIR ENTERTAINMENT. A magician, pictured above, and a weight lifter, seen below, entertain the crowd at the first Mira Mesa Street Fair on October 2, 1999. (Both PJS.)

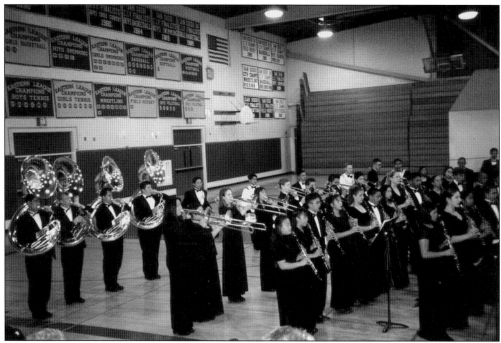

MIRA MESA HIGH SCHOOL BAND. The Mira Mesa High School Sapphire Sound Band provides a high level of music instruction for students and offers the community live musical entertainment during marching and concert seasons. Pictured is the Sapphire Sound performing a concert in the Mira Mesa High School gymnasium. (PJS.)

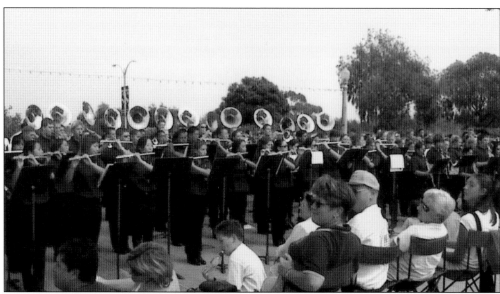

SYDNEY 2000 OLYMPIC BAND. The Mira Mesa High School Band was part of a mass band from multiple countries that participated in the opening ceremony of the 2000 Olympics in Sydney, Australia. In this picture, the band was playing a pre-Olympics performance for San Diegans at Balboa Park with the two other San Diego area schools that were part of the mass band. (PJS.)

Seven
INTO THE 21ST CENTURY

The story of Mira Mesa is the story of the birth of a diverse yet unified community. In the early days of Mira Mesa, mothers marched for local schools. As Mira Mesa's population grew, the services—schools, parks, shopping centers, and libraries—finally came, too. In the 1980s and 1990s Mira Mesans worked to balance community development and preservation of natural open space, enhancing their quality of life by protecting Los Peñasquitos Canyon Preserve, a San Diego City/County open space park. Western Mira Mesa, the area west of Camino Santa Fe often called "Sorrento Mesa," developed as a major industrial area with biotech and other technology firms.

As Mira Mesa entered the 2000s, the community approached build-out but still had several areas where significant new development was taking place. The Mira Mesa Street Fair grew as an annual community event. The Mira Mesa High School Foundation was created, as was HEROES, a neighbor helping neighbor, fix-it, clean-up, repair, and repaint it group. The Mira Mesa Town Council continued to hold monthly meetings to discuss community issues and sponsored programs to make Mira Mesa a better place to live.

Mira Mesa had a community newspaper in the early 1970s, the *Mira Mesa Times*. It folded, but one writer, Denise Stewart, became the editor and publisher of a new local newspaper, the *Rancho Mesa News*, which lasted until the early 1980s. The Mira Mesa/Scripps Ranch *Sentinel* was published under a variety of names as a weekly community newspaper from the 1970s until June 2009. A new era in communication within the community began with the July/August 2010 issue of *Mira Mesa Living*, a bimonthly publication with a Web site that is updated between print issues. Mira Mesa at the start of the 21st century has become a community that blends the best of feeling like a small town of its own but also being part of the city of San Diego as a whole.

MIRA MESA STREET FAIR ENTERS THE 2000S. At the Mira Mesa Street Fair in 2000, pictured above, the Mira Mesa Town Council booth is the place to go for answers to questions about the community. At the 2005 Mira Mesa Street Fair, seen below, a "big top" tent in the center of the fair brought together Mira Mesa's major volunteer civic groups so visitors could find out more about them all at once. The Mira Mesa Town Council, Mira Mesa Community Planning Group, and Mira Mesa Recreation Council joined forces to do the joint community information display. (Both PJS.)

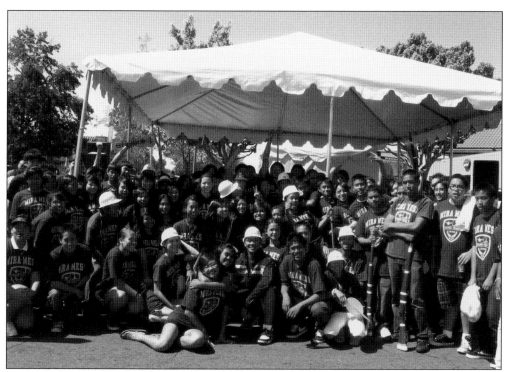

MIRA MESA HIGH SCHOOL **AFJROTC**. The Mira Mesa High School Air Force Junior Reserve Officer Training Corps provides invaluable assistance with the Mira Mesa Street Fair and other community events. This photograph was taken at the 2008 Mira Mesa Street Fair. (PJS.)

MIRA MESA STREET FAIR 2010. This view of the Mira Mesa Street Fair in 2010 looks south down Camino Ruiz toward Mira Mesa Boulevard. It was taken from the top of a very large earthmover and gives a bird's-eye view of the booths and people below. It also offers a chance to see just how much the street fair has grown since its beginning 11 years ago. (PJS.)

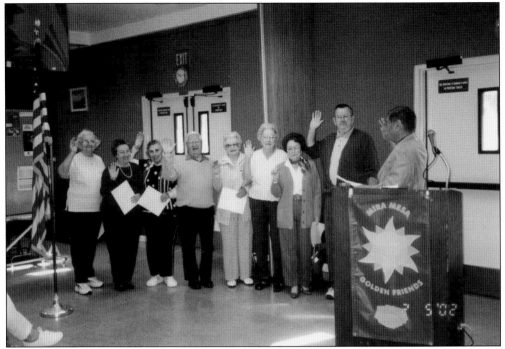

SWEARING IN THE GOLDEN FRIENDS BOARD. Resty Supnet, as chair of the board of governors of the Mira Mesa Senior Center, swears in the Board of the Golden Friends in May 2002. (LS.)

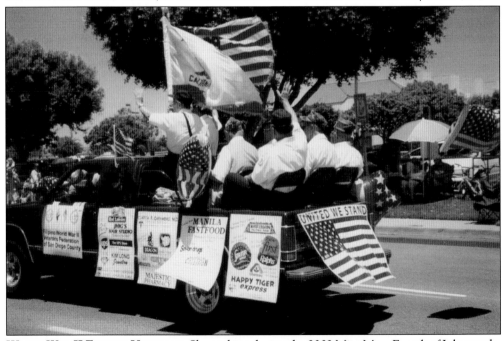

WORLD WAR II FILIPINO VETERANS. Shown here during the 2003 Mira Mesa Fourth of July parade, the Filipino World War II Veterans Federation of San Diego County celebrates the participation of Filipino soldiers during the occupation of the Philippines and works to get appropriate recognition by the federal government for this effort. (LS.)

MIRA MESA MONSTER MANOR 2004. The Mira Mesa Monster Manor began in 2001 and has become an annual tradition as a community haunted attraction, rising each October in the Target shopping center. Built and staffed by volunteers, the Monster Manor is designed for teens and adults to tour in the evening, but on weekend afternoons in late October, performs "Lite Frite" sessions geared for children. Pictured is Monster Manor in 2004. (PJS.)

TIM ALLEN. Mira Mesa resident Tim Allen was the creator of the Mira Mesa Monster Manor, bringing together other creative individuals who liked to build, act, or work behind the scenes to entertain people in a ghoulishly good fashion. The Monster Manor became a production of the Mira Mesa Theatre Guild, Mira Mesa's nonprofit community theater group. Shown at the dinner honoring him as 2003 volunteer of the year, Tim Allen was also active in the fight against abandoned shopping carts and was a friend of Sandburg Park. (PJS.)

MIRA MESA LIBRARY 10 YEAR CELEBRATION. The Samahan Philippine Dancers performed at a party celebrating the 10th anniversary of the current Mira Mesa Branch Library on Saturday, July 10, 2004. (PJS.)

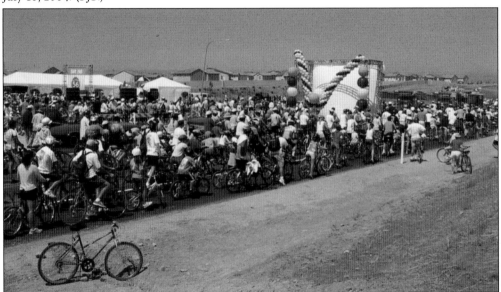

STATE ROUTE 56. On Saturday, July 17, 2004, many Mira Mesans were among the 10,000 people at the grand opening celebration for State Route 56, the long-awaited east–west freeway linking Rancho Peñasquitos and the Interstate 15 corridor to Carmel Valley and Interstate 5. For Mira Mesa in particular, the new freeway meant Mira Mesa Boulevard no longer had to carry displaced traffic that had to come south to commute from Rancho Peñasquitos to Sorrento Valley and other coastal employment centers. Those at the opening celebration had the opportunity for a special bike ride on the new highway. (PJS.)

CASINO NIGHT 2008. Mira Mesa resident John Daley added some zest to the 2008 Fourth of July Committee's Casino Night by donning Elvis attire for his gig as a volunteer dealer. The "gambling" is just for fun, since the real fund-raising comes from the silent auction and door prize raffles at the annual event. (PJS.)

BLOCK PARTY. Bari Vaz (pictured in the front row, fourth from left) organized this Neighborhood Watch Block Party to get neighbors together with each other in her section of The Village condominium complex in southeast Mira Mesa. (PJS.)

CAMINO RUIZ PARK. Another park initiated during the 1980s, Camino Ruiz Park, opened July 29, 2006. Because of a shortage of ballfields in Mira Mesa, the original design filled in a finger canyon to the south of the mesa and included five ballfields. This led to protests from neighbors and an intense series of community meetings to revise the park design. The result is this beautiful park on the edge of Los Peñasquitos Canyon with a trail around the outer edge of the park, native landscaping, and three ballfields. The park was designed by architect Glen Schmidt, shown below on the trail around the edge of the park. The picture above shows the ribbon cutting at the park opening. From left to right, San Diego mayor Jerry Sanders; Mira Mesa Recreation Council president Bruce Brown; San Diego city councilman Brian Maienschein with his daughter, Taylin; Mira Mesa Recreation Council chair Joe Frichtel holding his granddaughter, Shoney; and San Diego city park and recreation department director Ted Medina cut the ribbon. (Both PJS.)

MIRA MESA HENGE. Two pairs of pillars at Camino Ruiz Park are oriented to catch the sunset at the winter and summer solstices. Located in the northwest section of the park between the children's playground and the native plant garden, the pillars have a pair of benches facing them, a place to sit and relax while observing the scene. This photograph was taken on June 21, 2007. (PJS.)

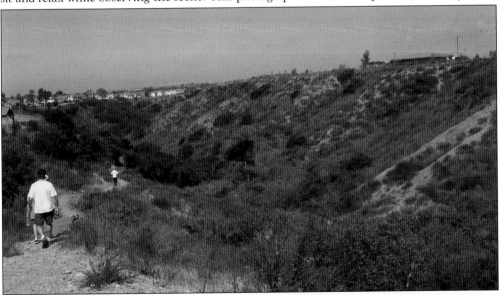

CAMINO RUIZ TRAIL. A later addition to Camino Ruiz Park is this trail into Los Peñasquitos Canyon Preserve, which opened August 8, 2009. The trail connects with the 6-mile-long east–west main trail at the bottom of Peñasquitos Canyon approximately 2 miles east of the waterfall. The trail is somewhat steep in the midsection but is suitable for a family hike and open to both hikers and bicyclists. It drops below the finger canyon rim and continues under a canopy of brush so that a large part of the hike is shaded. The round-trip hike to the Peñasquitos Canyon floor and back is about 1 mile. (PJS.)

MIRA MESA COMMUNITY PARK. This recently built attractive monument sign for Mira Mesa Community Park is located at the corner of Mira Mesa Boulevard and New Salem Street. The park is the site for a large number of special events, as well as individual use by families. Near this corner, a skateboarding plaza is proposed as a future amenity for the park. (PJS.)

PHILIPPINE FESTIVAL. Hosted by the Aguinaldo Foundation, this free cultural festival takes place each year in early to mid-June in Mira Mesa Community Park. In celebration of Philippine Independence Day on June 12, the festival takes place annually on a Saturday close to that date. Shown here at the all-day event in Mira Mesa Community Park in 2006 are Aguinaldo Foundation founder and president Zeny Ravelo, right, along with some of the "royalty" of that year's event. (PJS.)

SAN DIEGO TẾT FESTIVAL. The San Diego Tết Festival, sponsored by the Vietnamese Federation of San Diego, was held January 17–18, 2009, at Mira Mesa Community Park. In addition to entertainment, food booths, and other vendors and informational booths in the park, an art show and exhibit of floral arrangements took place in the meeting room of the Mira Mesa Branch Library. (PJS.)

CHALK THE WALK. Chalk drawings on the patio at the Mira Mesa Recreation Center were the focus of Chalk the Walk, held May 9, 2009, which was a fundraising event by the Mira Mesa Women's Club to help support art programs in local schools. The Mira Mesa Women's Club was originally organized in 1973 by Mira Mesa resident Jackie King as the Mira Mesa Junior Women's Club. The group graduated to Mira Mesa Women's Club in May 2007. (PJS.)

QUALCOMM. As the residential part of Mira Mesa developed to the east, a thriving high-tech industrial area developed to the west. The dividing line between residential and industrial development, at Camino Santa Fe, was determined by Marine Corps Air Station (previously Naval Air Station) Miramar overflight patterns. Because of the higher noise levels from Miramar jets in western Mira Mesa, this area was reserved for industrial development, which resulted in this extraordinary business area, as exemplified by the largest business, Qualcomm, shown in this October 2010 picture. (PJS.)

BEST BUY. In stark contrast to its reputation in the 1970s, Mira Mesa now has a great variety of stores. This Best Buy electronics store (shown in October 2010) is located on the northeast corner of Westview Parkway and Mira Mesa Boulevard. The current Mira Mesa Park-N-Ride for bus service to downtown San Diego is located east of Best Buy, with access from both Mira Mesa Boulevard westbound and from Westview Parkway via the north side of the Best Buy parking lot. (PJS.)

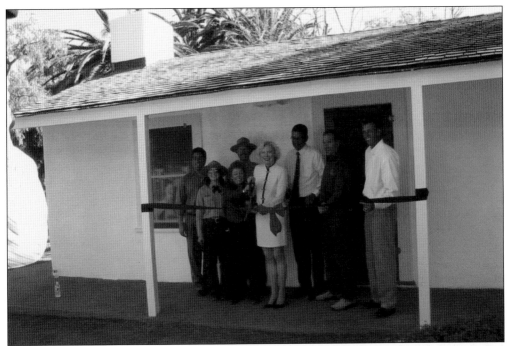

DEDICATION OF WING C, ADOBE RANCH HOUSE. The 150-year-old adobe ranch house in Los Peñasquitos Canyon was restored to close to its original state and is now open for visitors. The picture shows a ribbon cutting by county supervisor Pam Slater-Price at the completion of the restoration of Wing C, the kitchen wing of the ranch house, on November 7, 2006. The adobe is located between Mira Mesa and Rancho Peñasquitos at 12020 Black Mountain Road, at the west end of Canyonside Park Drive, west of the ballfields at Canyonside Park. (PJS).

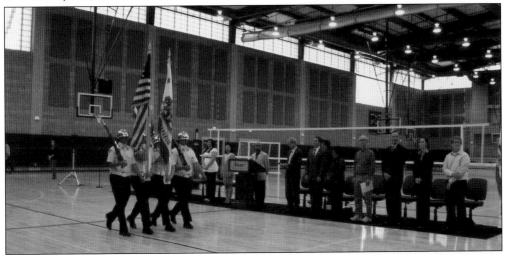

OPENING OF THE NEW FIELD HOUSE AT MIRAMAR COLLEGE. Another project initiated in the 1980s was joint use of recreation facilities at Miramar College. The college provided the land and community development fees paid to build Hourglass Field Park with several ballfields, as well as a swimming pool complex named the Ned Baumer Aquatic Center. College students and the community have access to both. The last phase of development was completion of this beautiful new field house, shown here at the opening ceremony on March 27, 2009. (PJS).

Mira Mesa Town Council. The Mira Mesa Town Council (MMTC) is still very active in the Mira Mesa Community. The picture shows the 2010 MMTC board of directors at a ceremonial swearing in ceremony on February 1, 2010, by city council member Carl DeMaio. Pictured, from left to right, are second vice president and membership chair Maria Pankau; board member at large Sandy Smith; newsletter editor Bari Vaz; board member at large John Daley; board member at large Mike Davis; secretary Hang Chau; board member at large Jon Labaw; president Ted Brengel; treasurer Jeff Stevens; and city councilman Carl DeMaio. (PJS.)

Progress on Salk Elementary School. School board member John Lee Evans told Mira Mesans the city of San Diego and the school district have worked out an agreement approved by the U.S. Fish and Wildlife Service for enhancement of vernal pool lands near Challenger Middle School. If construction starts in 2011 as planned, the new school could open for the 2013–2014 school year. (PJS.)

INDIAN DANCERS. Neha Patel's dance students are wearing traditional Hindu dance clothing. Patel is a teacher of traditional Indian dance and runs Antarnaad Studio. Mira Mesa's Little India square in southeast Mira Mesa on Black Mountain Road between Miramar Road and Activity Road includes the Hindu temple Shri Mandir and a variety of shops and restaurants. (TB and MT/MML.)

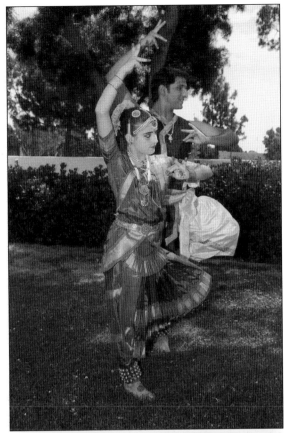

MIRA MESA GOLDEN FRIENDS. The Mira Mesa Golden Friends and the Filipino-American Senior Citizen Association (FASCA) are partners in running the Verne Goodwin Mira Mesa Senior Center through a board of governors that schedules activities and programs to benefit seniors and others in the community and also oversees rental of the facility to pay for its expenses. Pictured, from left to right, are (first row) Virginia Hollinger, Jan Hoch, Georgine Foster, Sarah Elfendahl, and Marian Burke; (second row) Gloria Supnet, John Malo, Sandy Smith, Lily Supnet, Bette Reynolds, and Robert Burke. (TB and MT/MML.)

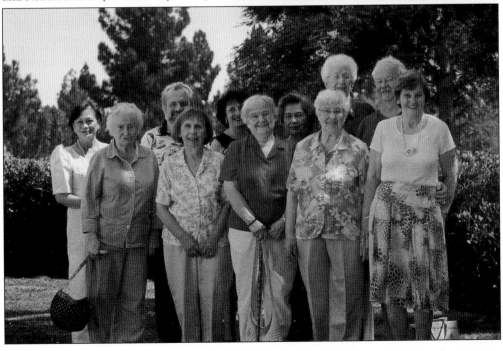

PACIFIC ISLANDER COMMUNITY. Tracy Ludwick, her four children, and friends are wearing traditional Pacific Islander costumes. Tracy and her girls are wearing muumuus, formal dresses worn in parts of Micronesia. Also shown is a lava-lava, a cloth fabric wrapped around the waist. Men generally wear this, and it is much less formal than the muumuu. (TB and MT/MML.)

MMHS ASIAN POP CULTURAL GROUP. The Rising Sun Asian Pop Cultural Group was created at Mira Mesa High School in 2008 as a club for all students who are interested in learning about Asian culture. The group meets at lunch on campus and discusses years of culture and history along with current events and modern fads. (TB and MT/MML.)

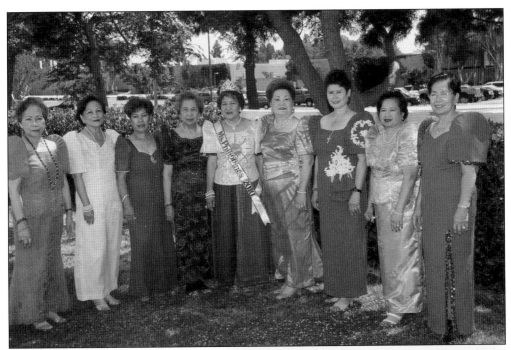

FASCA. The Filipino-American Senior Citizens Association (FASCA) is a partner with the Golden Friends in operating the Verne Goodwin Mira Mesa Senior Center. Like the Fil-Am Association of San Diego North County, FASCA's membership comes from Mira Mesa and from a larger regional area. Anyone over the age of 50, regardless of cultural background, can join FASCA. Shown above, from left to right, are Flory Garong, Gloria Supnet, Letty Wong, Lily Supnet, Carmen Suspine, Cora Anderson, Espie Gregorio, Baby Rionda, and Ester Cabuntucan. (TB and MT/MML.)

HMONG SEV. Kayla Fang wears a traditional Hmong sev (pronounced *shey*), a garment that is often worn at weddings by the bride and groom. (TB and MT/MML.)

MIRA MESA LIVING. Mira Mesa is a happily multiethnic community. This picture of people in the Mira Mesa community was taken by photographer Ted Brengel for the cover of the September/

October 2010 issue of the new *Mira Mesa Living* magazine, which is edited and published by Michelle Tsai. It is now printed every two months in Mira Mesa. (TB and MT/MML.)

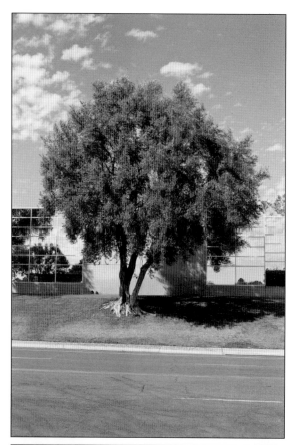

THE OLIVE GROVE TODAY. The olive grove, which predated any of the houses in Mira Mesa, still exists near its original location (see page 16). When the business area was developed in the mid-1980s, the olive trees were transplanted and became part of the landscaping for the businesses along Flanders Drive, as shown in these two pictures. Driving along Flanders Drive west of Camino Santa Fe offers an opportunity to notice the mature olive trees among the modern reflective glass office buildings and see Mira Mesa as it once was, as well as to reflect on what it is today and envision what the community will become in the future. (Both TB.)

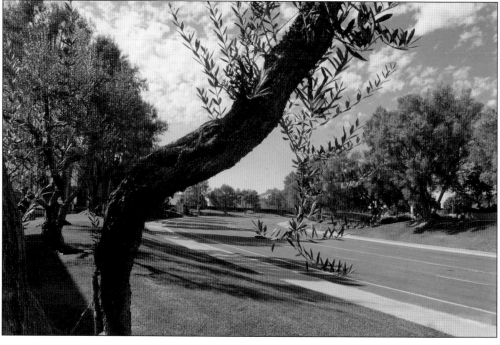

BIBLIOGRAPHY

Christenson, Lynne Newell, Ph.D., and Ellen L. Sweet. *Ranchos of San Diego County*. Charleston, South Carolina: Arcadia Publishing, 2008.
Fetzer, Leland. *San Diego County Place Names, A to Z*. San Diego, CA: Sunbelt Publications, Inc., 2005.
Miramar College, 2008–2009 Annual Report. www.sdmiramar.edu/annual/
Patacsil, Judy, Rudy Guevarra, Jr., and Felix Tuyay, Filipino American National Historical Society, San Diego Chapter. *Filipinos in San Diego*. Charleston, South Carolina: Arcadia Publishing, 2010.
Peters, Ruby Mae; *Miramar Before the Planes: of the U.S. Naval Air Station at San Diego, California; a rural settlement and one room school 1890–1950*. San Diego, California: 1984.
www.harmoniumsd.org
www.miramesaseniorcenter.org
www.miramesatowncouncil.org
www.mmwomensclub.com
www.penasquitos.org

www.arcadiapublishing.com

Discover books about the town where you grew up, the cities where your friends and families live, the town where your parents met, or even that retirement spot you've been dreaming about. Our Web site provides history lovers with exclusive deals, advanced notification about new titles, e-mail alerts of author events, and much more.

MADE IN THE USA

Arcadia Publishing, the leading local history publisher in the United States, is committed to making history accessible and meaningful through publishing books that celebrate and preserve the heritage of America's people and places. Consistent with our mission to preserve history on a local level, this book was printed in South Carolina on American-made paper and manufactured entirely in the United States.

This book carries the accredited Forest Stewardship Council (FSC) label and is printed on 100 percent FSC-certified paper. Products carrying the FSC label are independently certified to assure consumers that they come from forests that are managed to meet the social, economic, and ecological needs of present and future generations.

FSC
Mixed Sources
Product group from well-managed forests and other controlled sources

Cert no. SW-COC-001530
www.fsc.org
© 1996 Forest Stewardship Council

Find Your Place in History.